A.T. SCHAEFER
METAMORPHOSES
WORKS 1989·1996

In association with

Kunsthalle Bielefeld
Museum für Kunst und Gewerbe Hamburg

A.T. SCHAEFER
METAMORPHOSES
WORKS 1989 - 1996

Edited by Jutta Hülsewig-Johnen

*E*DITION *S*TEMMLE

CONTENTS

PLACES OF COLOR

The Photographs of A.T. Schaefer

Are we peering into the apparent infinity of a deep blue and almost unruffled sea? Has some gauzy material been cast over the picture foreground? Say a fishing-net? Or is it some substance hard as glass that gives rise to the diagonals visible there? Is it shimmering dark blue-black crystalline structures on the surface of a stone? In ice? White glints of reflected light on a dark sheet of ice whose fissures and faults, scratches and edges emerge as bizarre structures? And this the sheen like gold on the surface of a piece of wood? Or this: red cloth, woven fabric? Is it drapery folds we make out?

While these photographs peculiarly show us structures from a world of material things, they pay little or no heed to contexts of that world, and the viewer's eye does not recognise it easily. It is an unaccustomed view. In some cases the view is so close-up as to have wrenched what it shows out of any context of material objects. In other pictures, the eye is led as if into a far distance, but no sense of location ensues. A.T. Schaefer's photographs hold the viewer's eye and challenge it. The challenge is not easy.

The color in these photographs has invoked descriptions such as "gorgeous",[1] and there is no need to shun the term. Color is so striking in Schaefer's work that it radiates from the photographs and hits you directly, bypassing any intercession of reflective reason; it resonates at the sensory level, in the sensing, emotive, primary apperception of these picture creations, pays homage to beauty, but so forcefully that it is never flattery for our expectations. What is worse, the effect does not stop at this level of emotional sensation; the luminosity of these photographic pictures is also the vehicle of structures which niggle the ordering urge of the intellect.

Our unease at finding ourselves thrown out of cosy visual habits is redoubled because the medium is photography – so familiar in practice and result that our conditioned perception normally holds even where photography is not the utterly banal everyday operation, but a means of artistic composition, liberated from all banal purposes and with quite different intentions. Much more than in a painting or drawing, when we look at a photograph we are motivated by the expectation that we will recognise the subject.

The photograph begs this anticipating attitude, because photography has a now long-standing tradition, almost without exception, of providing a picture of the world in a particularly simple way. In a photograph, anyone who wants to can take home a piece of the world, appropriate the desired object, become the owner of a supposedly true-to-life image: can have literally his own picture of the world. In all these contexts, the photograph's purpose is to help understand the world by better perceiving it.[2]

Even though this passing century had hardly begun when art crossed the base line from representation to the abstract and so released artistic composition

1 Dorothee Hammerstein, quoted from *Das Foto als autonomes Bild. Experimentelle Gestaltung 1839-1989,* eds. J. Hülsewig-Johnen, G. Jäger and J. A. Schmoll called Eisenwerth (Bielefeld/ Stuttgart, 1989), p. 178.

2 Susan Sontag, *On Photography* (New York, 1977), cited from German edn (Munich, 1978), p. 9 ff.

from its centuries-old bond to the forms of nature and the material world in imitating or idealising them, it accords to our habits of visual perception to expect "recognisability", i.e., we look forward to rediscovering familiar object forms be it in a picture, a view, or indeed a new and therefore unfamiliar artistic creation.

This is especially true when we look at a photograph, because the main purpose of photography to this day is not artistic design, but documentation. The mechanical process of photographic recording is credited with incorruptibility and its product with authenticity, irrespective of the element of subjectivity that every photograph necessarily inherits from the individual photographer. The photograph is seen as a survey "taken" of what it shows, a situation or location, a state. The photograph testifies to us as to what something was or is like – it has the authority of proof. When we look at a photograph, therefore, we see as a rule not the peculiarities of the photographic image, but those of the situation shown. As a rule, this most accustomed perception of all is the appropriate one, and corresponds to what the photograph was intended for. The process of recognition has us tally what we see, perhaps for the first time, with what we know. Accrued individual experience of life gives us the stock of knowledge about the formal phenomena in our day-to-day environment which form the basis for this comparison. Each new manifestation encountered is filed in the pool according to the stock of known formulas for one's experience of the world, stored in the mind. The more readily it finds its place in the pool, the more readily we "recognise" such a manifestation: that is, the more readily we can sort the multiple forms of our individual experience of the world into the realms either of the familiar, and thus, of assured possession, or of the unknown and possibly dangerous.

The work of art commonly referred to as "abstract" no longer derives its formal structures from the pool of known and accustomed manifestations of the world, but presents the viewer with invented, unknown and unaccustomed structures. The effects which many viewers to this day find irritating if not downright provocative (and that with surprising frequency), derive from the simple circumstance that the picture's vocabulary refuses to be slotted into the safe, pigeon-hole treasury of what is already known: it is thus apt to acquire threatening qualities or at any rate, to exacts efforts to come to terms with the unfamiliar world of its forms.

We are at the close of a century that has confronted us, in "non-representational art", with utterly new, previously unseen realities of a picture's own – with new dimensions of artistic invention; it has accustomed us to engaging in that encounter; but the categorising habit dies hard or not at all. Whether we are willing to really look at a picture still very commonly depends on our distinction between representational and non-representational images, between "recognisable" and "not recognisable" pictorial content as the persistent criterion of whether a picture's message is accessible or not.

To put it another way: whether we can recognise a depiction, that is, identify its forms by comparison with the accustomed appearance of the world, or if

we cannot, how we respond to the consequence, the challenge not to dismiss new, unfamiliar constellations, much determines our subsequent dealings with a picture's structures. It appears as if, in a hypothetical chart of pictorial composition types, Schaefer were lodging his directly at the intersection of the axes of representation and non-representation. That he does so through the medium of photography does nothing to make our approach to his pictures any easier.

To pose my introductory questions, at any rate, promises no light at this stage, and if they take us anywhere, it is wide of the center of these worlds of color and form. Answers cannot, for the most part, be found, and even to seek them seems obsolete the more one contemplates the work. As the representational references of these photographs lose relevance, so their visual autonomy gains in significance. The picture asserts its effect as a composition of colors and shapes; and ultimately, only the picture's own, self-sufficient laws of formation can provide the key for an understanding of the constellation it presents.[3] Often, however, the visual structures from which these laws arise offer traces from a familiar world of objects and circumstances, known through daily optical reference, whose appearance of "recognisability" is an immediate and powerful stimulus to perception.

The non-material vehicle for the image as we perceive it is a dramatic tension. Tension is generated between the two poles of the photographic image, from its relating to objects by "reproducing" a subject to the autonomy of the artistic statement – i. e., in the criteria governing the optical organisation of the reproduction in a photograph. But it does not follow that there is a convenient formula for the visual organisation of the image we see, with a constant such as the mid-point between these poles: the image may manifest itself at any, variable point on this imaginary scale between the reproduction of a subject and complete autonomy, the self-sufficient image. Artistic effect and statement are defined by the degree of gradual shift in one direction or the other, depending upon the artistic concept, wich may extend all the way to the composition that, freed of any hint of object connotation, is totally abstract. And this "degree of shift" is the viewer's guide to the pictorial universe. A closer look at the optical organisation of the pictorial manifestation is therefore crucial, both for an understanding of the way these pictures work and because simply pointing out the experimental aspect of his exploration of the technical potential of his medium is not to understand A. T. Schaefer's photographs. His starting point is a good deal more complex.

Genuine photo-technical experimentation, it could be said, exploits the technical characteristics of the medium itself, with or without a camera, mostly in a way other than the corresponding instruction manual would prescribe. The viewer and, often enough, the photographer, are surprised by pictorial effects created in arbitrary interventions in the technical processes under contingent – in other words experimental – conditions: the aim is so declaredly experimental that we are willing at the outset to acquiesce in the use of the photographic medium in total disregard of its traditional

3 For any closer consideration of such questions of a picture's effect and the modes of perception of forms in pictorial design, Max Imdahl's distinction between "seeing" and "recognitory" vision is absolutely crucial. Cf. Max Imdahl, "Cézanne – Braque – Picasso/ Zum Verhältnis zwischen Bildautonomie und Gegenstandssehen" in *Wallraf-Richartz-Jahrbuch* vol. 36 (Cologne, 1974), p. 525 ff.

documentary mandate. In contrast, Schaefer's photographs always have their definite point of departure, their "source location" in the motif to which he has taken the camera. Both in relating to a specific, nameable motif and in the classical method of fixing it, namely, with a camera, the works are conventional. They are also conventional in the sense that the motif needs to be a very conscious choice with regard to the intended pictorial effect.

But the photographic image does not begin and end with the reproduction of the motif photographed, in what the camera has recorded by mechanical procedure with all the precision of the technical process; in the continuing artistic process it is subjected to greater or lesser modification according to the intended artistic statement. To this extent, the work is experimental. It is also experimental in that it puts our habits of perception to the test.

Then again, the experimental aspect does not consist in the exploitation of the medium's technical potential in its own right, in the sense of a free, strictly speaking inappropriate application, or in the inclusion of chance configurations such as might be obtained by fortuitous chemical reactions in the process of pictorial discovery; the experiment here consists in the controlled further development of the given, photographed source motif until the desired pictorial effect is obtained, which in turn releases the anticipated view qualities on the basis of the photographed motif. Thus, the completed picture inevitably goes beyond an optical reproduction of the source motif situation, attaining a state of manifestation in its own right. The photograph can no longer be identified as a "likeness"; and yet it retains, with a transformed function, those irritating vestiges of reference to a motif outside its own material that prompt the kind of question I suggested by way of introduction. In a literal sense, though, the world of these pictures is fundamentally abstract, quite apart from the consideration that any photograph, being able to reproduce a three-dimensional reality only in two dimensions, must be an abstraction – the Latin root verb *abstrahere* translating as "drawing away from". A photograph has been abstracted out of the everyday reality of our object world, developed out of it to become its own reality.

Where and how far a Schaefer piece is taken in its development from the original viewfinder motif to the completed artistic statement is essentially a matter of how color is brought to bear in the picture's formal, compositional structure. In other words, when he judges the color to have reached the pitch ordained by the artistic concept, the composition itself at its optimum. The manifest picture emerging from this process of development is therefore necessarily and critically dominated by the effects of the color: it can be said that the autonomy of the final manifestation as a picture is a direct effect of the sovereignty of the color manifestation.

Schaefer is already consciously tapping the color values inherent in the motif, his eye already on the ultimate appearance of the picture, when he takes his photograph. He then develops them so far that they ultimately predominate over the recognisability of the object sources of the image, what it is becoming insignificant by comparison – the unnoticed structural, formal and subtle

presence that supports the pictorial composition. The formal structures thus derive from the substance of the original motif, but have been modified along with the color effects in the developing of the picture, the criterion again being the formal necessities of the composition. This process can extend to the radical pivoting of the pictorial axes. In the final result the directional forces of the source motif may have been turned by ninety degrees or even reversed. It is to this formal framework that the qualities of recognisability are essentially attached. Here the eye finds a hold to seek familiar, that is, identifiable structures, even though the predominant color effects dominating have evolved quite away from any such structuring, and in their optical force overlay and even seem to inundate the picture space, overwhelming all the formal values couched within it.

Thus, the development that is most instrumental in these photo pieces is much broader than the technical process we immediately associate with photography. The crucial process in Schaefer's hands is one of setting off a release of color and form as factors from the source motif until the complete photographic picture is attained, and of stopping them at this successful conclusion. At this crucial point of arrest, the color has been isolated out of its local integration in the formal basic constellations of the motif as photographed, and, its effect now enhanced, stands in its own right – developed into the "chromatic tone" of a composition whose appearance is now largely governed by it and resides in a formal order of its own, independent of any object reference. The most radical outcome of this process of development is the reversal of the ground color of the motif into its complementary, or opposite on the color circle during the technical completion of the print in the photo laboratory. If the viewer pictures the color circle with its primary colors and the secondary colors resulting from their blending (red, blue and yellow, and green, orange and violet), then the pictorial composition appears as if mirrored on the other side of the color axis, in the complementary color to that of the motif, a "color symmetry". This color reflection may also become a formative element in the picture in its own right, in wich case the subject of the composition is the complementary color tone in its harmonious contrast.

In the course of his exploration of color in photography, Schaefer proceeds to add to this fundamental theme in visual art the decisive aspect which the medium of the photograph is better suited than any to lend visual, artistic expression – namely, light. The perception of color and the effect of light are inextricably bound. Our eyes know no color perception in the absence of light; as the proverb observes, in the dark all cats are gray. Color is the manifestation of light our eyes are most familiar with and most directly impressed by. White light contains all colors and their spectrum becomes visible to our eyes when white light rays pass through a prism, as the reflection of sunlight in drops of rain creates the vivid play of colors that is a rainbow – the color spectrum of the sunlight we normally perceive as white. Only "in light" will an object, no matter what it may be, acquire color for our eyes: when its surface absorbs all the color elements in the rays of light striking it apart from

those it reflects, which we perceive as the object's "surface color". If we accept this absolute dependence of color upon light, it is even more astonishing that the history of "drawing in light", if we take *photo-graphy* etymologically, has not gone hand in hand with a history of the pictorial representation of color; the more so in view of the centuries that artists and art theorists have spent investigating color along with other visual phenomena. Certainly one hindrance will have been that for a long time after its invention in the mid-nineteenth century,[4] photographic image production was not capable of reproducing color. There simply was not the technology. Even so, it is surprising that through subsequent decades, into the twentieth century (with color photography soon technological routine) and almost to the present day, though used as a matter of course in any photographic record considered worthy of being called a "true-to-life" document, color in "classical", camera-based photography has been more an optional extra than an essential constituent of its artistic worth. One reason may be that photography's greatest artistic potential would seem to place it amongst the technically more germane black-and-white arts of printmaking than with painting. The accent in the picture as a product of "drawing in light" lay there rather than in light's chromatic aspects. A.T. Schaefer's "light pictures" decidedly and consistently appear as "color pictures" – consistent, perhaps, with the artist's roots in painting.

Color is not an adjunct, but the essence and soul of these pictorial realities. They would be inconceivable were they not wholly suffused with their own, intense colored light. Materialising light as the necessary condition for their visible existence, they materialise light as color. For light appears here not as lighting, as a factor applied externally to the color structures, but as the medium by which the once recorded reality becomes manifest as pictorial reality, between the brightest white in which all colors are concentrated and the virtually lightless black of the profoundest darks. Conversely, the luminosity of color becomes material in the consistency and textures of the motif as they become factors in the picture. From the mutual dependence of light, color and form issues a new, pictorial reality in which the original photographic source motif or "original location" has developed into a location for color: a "place of color", the set where the slice of the real world that enters the photograph is manifest now through its own color tone, one might say as that tone. The photograph is taken with carefully calculated exposure times. The frequently long-exposed (long-lit!) photographic image transforms the reality of the motif into pictorial reality by concentrating the largely circumstantial material consistency of the chosen original location at the time the photograph was taken upon the underlying key tone nuance and raising this to the dominant feature, quite possibly complementary to the motif: the composition now optically follows its own color tone, is tuned overall to its inherent key.

Schaefer's photographs consequently show not a turquoise or deep blue iridescent sea – not a section of wood grain struck by what might be the intense yellow rays of the sun at evening – not ice shimmering white and blue-black. What they show is the array of nuances, say of an intense blue materialised

4 Cf. note 1. Jutta Hülsewig-Johnen, "Bildautonomie. Fotos aus neuen Welten" in Hülsewig-Johnen et al. (eds.), 1989, p. 11 ff.

in crystalline structures; a tone iridescent between reddish brown and light yellow, as manifested on the surface structures of wood; intense deep red shot through locally with white, tactile and vivid in the picture-ground which emerges, albeit as background information, as a textile fabric source. Ultimately the physical support substance becomes literally immaterial for the presence of the associated color and it becomes virtually impossible to retrace such direct connections from the image to the source motif. All this attempts to describe one phenomenon – the reversal of our habits of perception. Nothing less occurs when we look at these photographs. Whereas the rule in our accustomed manner of perceiving of objects is that the optical experience of our environment is guided, as described, by categorising it into what is known and what is not, these pictural realities, even in and despite the presence of identifiable elements of representational motifs, are always perceived first and foremost in their color and form values. In the visual perception of the composition, its presence as color always prevails over the habitual ordering perception of the structures of known objects.

This reversal of our perceptual habits in its recourse to recognition of the world of objects, so that we perceive by experiencing optically without the slightest hint of an act of identification, has been called by Max Imdahl a reversal of the customary "recognitory vision" into "seeing vision". That expresses it in a nutshell.[5] "Seeing vision" apperceives the optical circumstances of the visible world, irrespective of intellectual, preconceived systematisations of that world through prior ideas and knowledge. This other kind of vision allows the eye to experience without preconception,[6] in an autonomous optical act of perception. In "recognitory vision", perception of the object world merely implies a process in which the visual encounter with the real thing elicits "the concept of [an] object as preset in the beholder".[7] "Seeing vision" admits the presence of the object world untrammeled by any preconceptions, as a purely optical system of color and form relationships, color values and contrasts of light and shade, needing no verification according to their representational accuracy, but possessing their own worth as optical phenomena. This principle underlies A.T. Schaefer's photographs, in them, "seeing vision" prevails convincingly over "recognitory vision". By reversing the perceptual priorities of object structures in the motif and the purely visually relevant manifestation of the motif situation as a system of color and form relations – in favour of a tone, a color resonance enhanced to the point of complete optical autonomy within the photographic picture – the picture itself prompts this mode of perception: the experience of the pictorial reality becomes independent of any recognition of a reproduced, motif reality.

True to the perception of "seeing vision", then, the photographic image in Schaefer's hands succeeds in liberating from the source motif as photographed at the "original motif location" its pure "values of visibility", as Imdahl terms them, so that they become the final picture's keynote color. The photograph, in its pictorial self-evidence and self-sufficiency, enables this key tone to become very real as a purely optical experience free of con-

5 See note 3
6 Cf. Dieter Henrich, *Kunst und Kunstphilosophie der Gegenwart, Immanente Ästhetik, Ästhetische Reflexion* (Munich, 1966), p. 11 ff.
7 Max Imdahl, *Wallraf-Richartz-Jahrbuch*, p. 325.

ceptual or representational connotations. But this is not to say that the pure optical experience intended in the photographic picture is a chance, random invention. It has been developed out of the photograph's source motif. "Taken" by the camera lens in all its precision, the purpose of the shot is not to reproduce the reality of the motif situation, but to liberate what "seeing vision" is able to perceive: the fundamental features of the original location in the purely optical sense of its salient structures of color and form. Their context in terms of objects is no longer relevant.

The unimpeachable objectivity so often attributed to the eye of the camera, harnessed as in this work to that "seeing vision" untroubled by preconceived notions of the material world, is redirected exclusively to those aspects of the original situation which can be apperceived purely in optical terms, i.e., its reality of appearance, that aspect which terms like "atmosphere" or "mood" of place can only convey inadequately, because they are inappropriate for a purely visual response. "Seeing vision" apperceives it immediately; but it eludes translation into concepts. Precisely this paradox between what is visually evident and the impossibility of finding adequate concepts for it highlights the perceptual feat that "seeing vision" is capable of, as the autonomous eye which the art theorist, Conrad Fiedler, described in his pioneering way as the lifeline of genuine perception and expression in fine art as long ago as the late nineteenth century.[8]

The technically highly sophisticated, "objective" eye of the camera has been developed to perfection in its precise optics. It was invented to achieve the most precise depiction of any object it is pointed at, as a tool for the intellectual appropriation of the environment. A.T. Schaefer puts it to utterly different uses. His aim is an altered mode of perception. The technical precision instrument serves to enhance a faculty of vision concerned with recording a purely visual reality of appearance of any given motif, a "pre-conceptual" as opposed to "preconceived" view. This reality is manifest not as a world of objects, but as one of colors and shapes as well. The issue is not its intellectual recording and appropriation, but sensory experience and knowledge. Schäfer uses the eye of the camera to heighten in our own eye. It is the faculty of cognition of the autonomous eye whose experiences and perceptions from a world of sensory actuality, passing through the technically incorruptible recording medium, are distilled and objectified in the photographic picture to appear as a monumental presence. To look at the pictural reality: an assertion everywhere of pre-conceptual features catches the eye as otherwise would not: optical qualities lifted from the world of objects; qualities which the eye, still loth to relinquish the lifeline routine of recognitory vision, is wont to overlook. It wants its convenient object identifications; sees what the mind dictates *ought* to be seen. In Schaefer's pictures, the plane of "seeing vision", of pure optical sensory perception that lies before any identification of objects, is activated and given priority over the plane of "recognitory vision", albeit without entirely putting it out of action: cognition always remains a subcurrent, carried on the formal structures of the pictorial reality and still effective in it.

8 Conrad Fiedler, *Schriften über Kunst*. Introduction by Hans Eckstein (Cologne, 1977). In the above context, the item entitled "Ursprung der künstlerischen Tätigkeit", is highly illuminating (p. 131 ff.).

The image exacts awareness on both planes of vision. The "recognitory" perception of objects is heightened by "seeing vision', the accustomed intellectual cognition complemented and extended by sensual understanding. The image, by virtue of its optical quality, elicits greatly enhanced acts of vision. In such perception is rooted the vivid intensity of the composition. Paradoxically, some of the most cogent evidence for the above comes where Schaefer's choice of subject in the finished piece is primarily and quite clearly representational in intent.

His treatments of the broad theme of opera, inspired by productions at the Opera House in Stuttgart,[9] appear quite obviously to differ from the compositions discussed above, both in the intention and the formal organisation of the picture. A second glance at the opera pictures already mutes the sensation of difference as one becomes aware of the fundamental kinship between the works on the opera and those on color. In both these thematic cycles, one underlying mode of perception is expressed, and underlying that in turn is what I have described above as the intensification of the capacity of sight through the activation of the planes of both recognitory and seeing vision. The difference in the two cycles is one of pictorial emphasis only. The pictures on color are necessarily organised to satisfy the dominant criteria of seeing vision, that plane being where pure color vision takes place as sensory-optic apperception. The plane of recognitory vision underlies that of seeing vision, because color perceived has been developed out of the objective resource of the motif by which the picture's formal composition is organised. The content and message of the works on color is color itself, that is, a pre-conceptual (primal), purely optical-sensory experience which, by enhancing perception, also puts the world of everyday existence into a new light. The pictorial reality has no ether content to convey, no other tale to tell and no purpose other than to heighten awareness of the world of things as a world of appearances. Aided by photography's precision, by a technology which amplifies the eye's processes of vision, that world is given enhanced pictorial, i.e., visual expression. In contrast, the opera pictures do speak of external matters against the background of their own pictorial structure – namely those from the world of the theater. They tell of the complex events at an opera performance. They are action stills from a narrative developing continuously on stage, again organised into pictures in the shape of scenes; but in the source situation, the content cannot be conveyed and perceived via the visual channel alone; it is patently also an acoustic experience.

The present context does not permit anything like an adequate examination of the way Schaefer's opera pictures work in comparison to the complex event of a performance, but one aspect of his organisation of his pictures is illuminating nonetheless. While the works on the opera necessarily reduce events on stage to a purely visual, pictorial, two-dimensional reality, and are therefore extremely abstract in relation to the source motif, this pictorial reduction is still able, despite its sacrificing most of the potential of effect specific to the opera experience, to make aspects of the stage event tangible in a special way.

9 Published in A.T. Schaefer, *Oper in Stuttgart* (Hamburg: Verlag U. Schönewald, 1995).

True, the photographed image is necessarily a reduction out of the complex overall event, but through his distillation, Schaefer attains the paradox of saying most by saying less.- He concentrates his composition on the visual elements of the performance, precisely the constellations of colors and forms which the stage event, obviously, likewise directs at the spectator's optical perception and therefore likewise organises according to pictorial, visual criteria in a scene or stage-set context. He optically arrests their motion and offers them to the eye in concentrated and literally quiet form, without involvement of the participation of the acoustic faculties. Thus the photographic least even intensifies our perception of the visual elements: it is on the plane of seeing vision that we perceive the color and formal constellations characterising the stage event, or rather, perceive it as a constellation of colors and shapes. So in the opera photographs, too, the findings regarding this plane of seeing, concerned as it is with pre-conceptual, purely optical structures, apply in the pictorial scheme. But they relate to those produced by the usual kind of vision-by-recognition, geared to categorised object perceptions, in a different way from the equally original vision in the works on color.

The difference between the color pictures and the opera pictures could be expressed as the reversal between them of the degree of influence in the respective composition, of the planes of seeing and recognitory vision. If in the color works, the findings of seeing vision necessarily prevail, then in the opera pictures the findings of recognitory vision come to bear, since the pictorial intention must follow the necessities of reproducing the photographed motif. However, since the findings of seeing vision are also relevant to such reproduction and enter into the organisation of the picture accordingly, the costomary perception of objects is intensified to a particularly high pitch by the perception of the color and formal constellations simultaneously present in that organisation.

The findings of pre-conceptual optical-sensory experience underlie the representational, narrative image structure, so that in the opera pictures, too, both planes of perception are always at work. The consequence is not least the intensity of their joint effect, by which the photographic image can make tangible – through the visual experience alone – sensations and experiences out of the event of opera.

Jutta Hülsewig-Johnen

PLATES

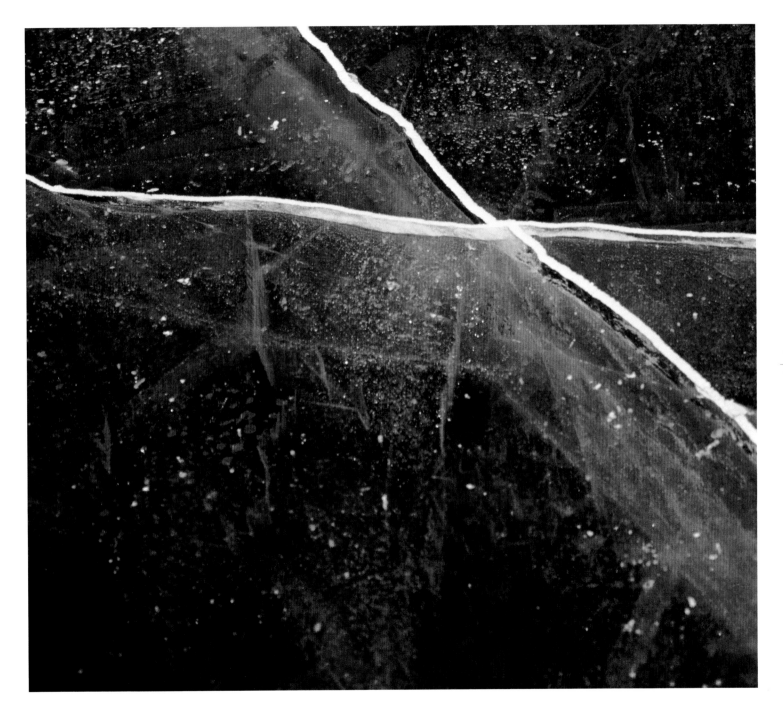

ENGADIN I.
65 x 80 cm
1989/95

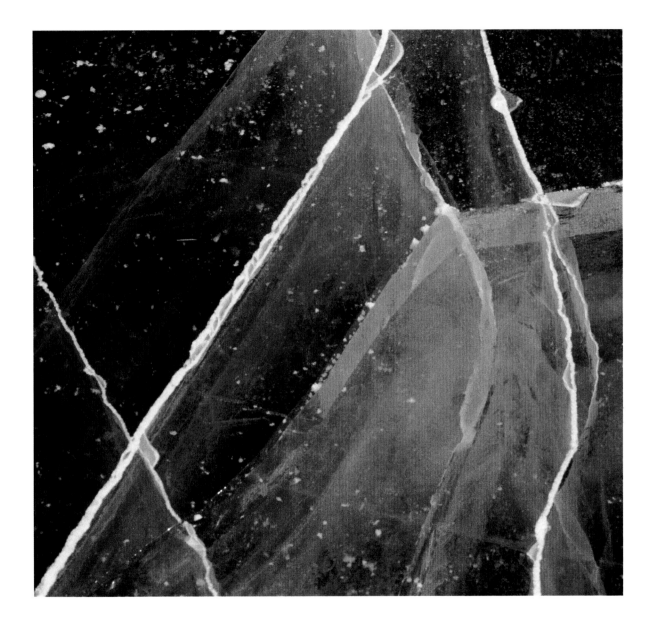

ENGADIN III.
72 x 80 cm
1989/95

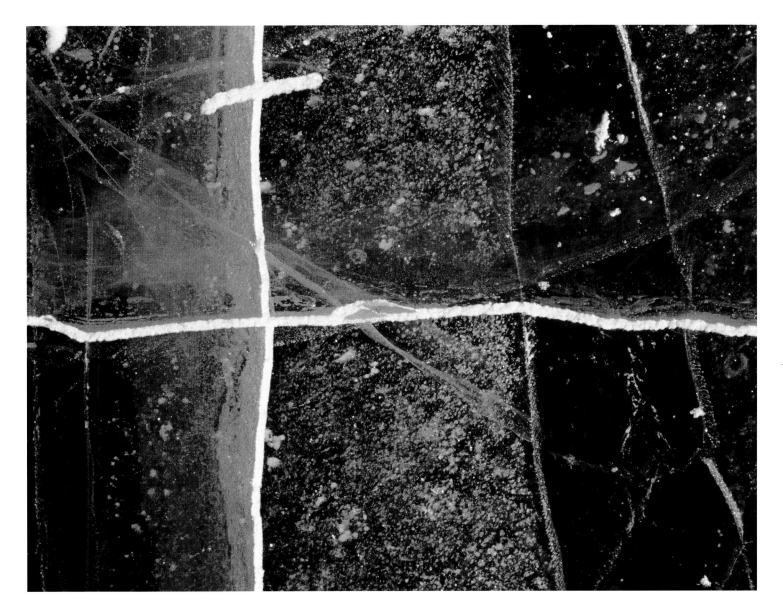

ENGADIN II.
72,7 x 80 cm
1989/95

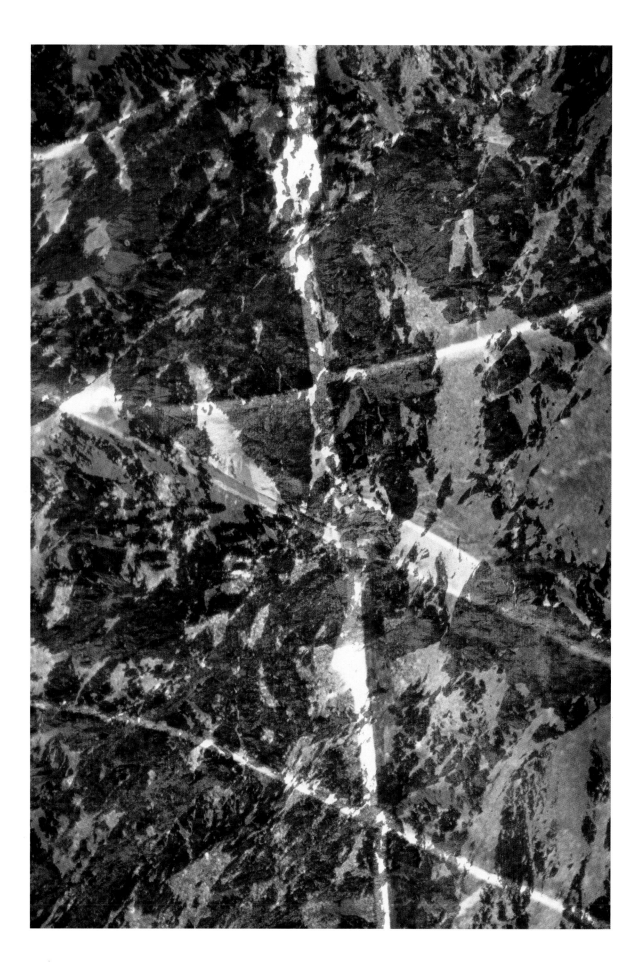

ENGADIN IV.
120 x 80 cm
1989/95

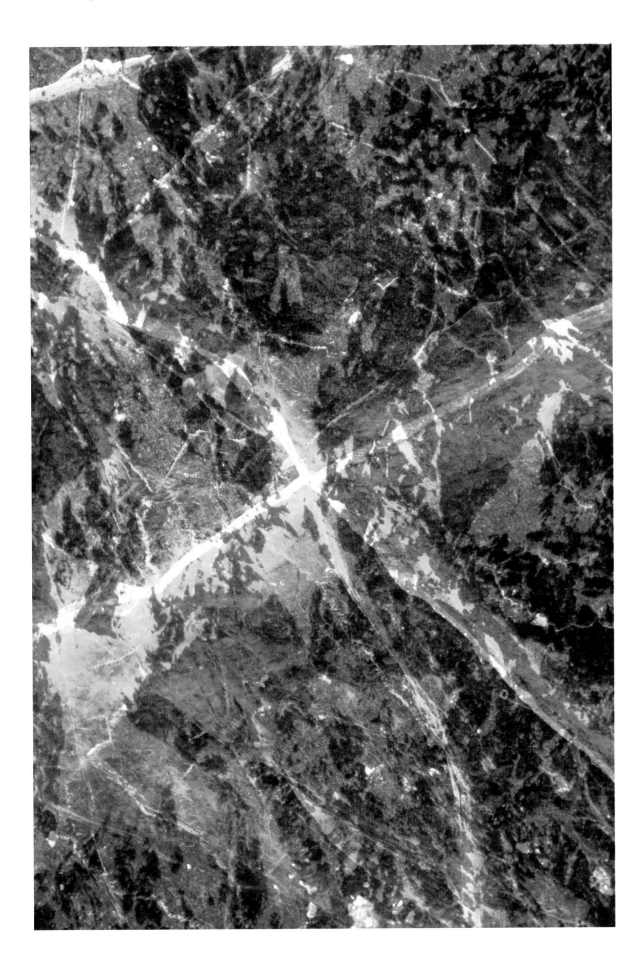

O.T.
120 x 80 cm
1992

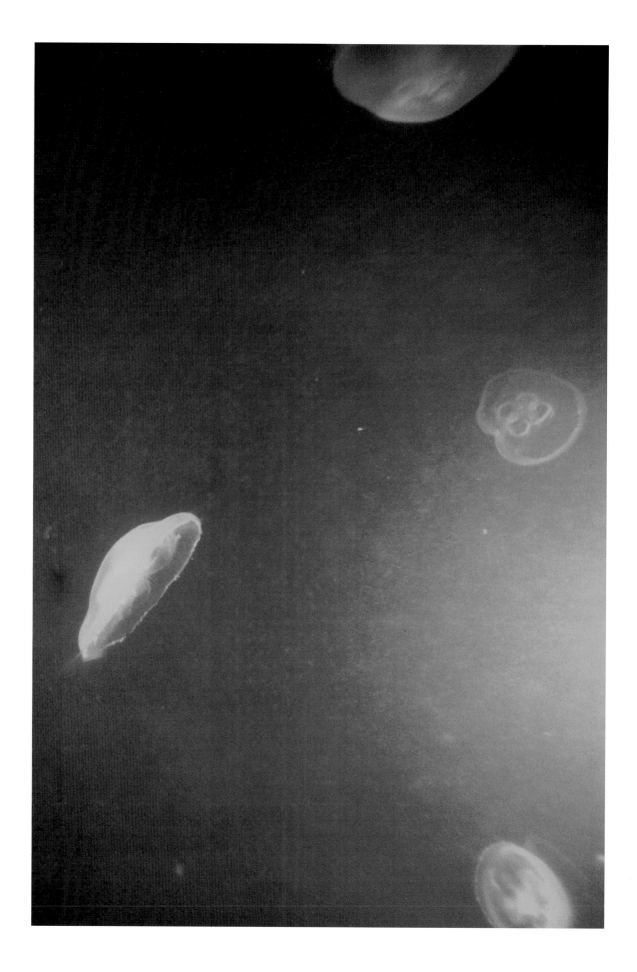

O.T.
160 x 110 cm
1995

O.T.
160 x 110 cm
1995

O.T.
160 x 110 cm
1995

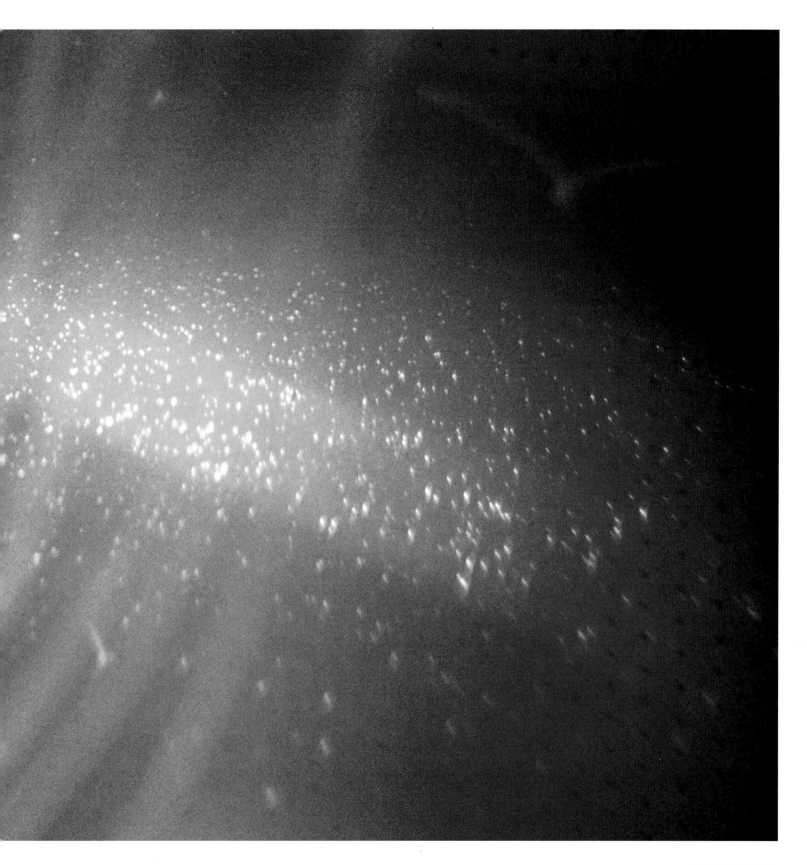

NORDLICHT I
125 x 241 cm
1995

O.T.
110 x 160 cm
1990/94

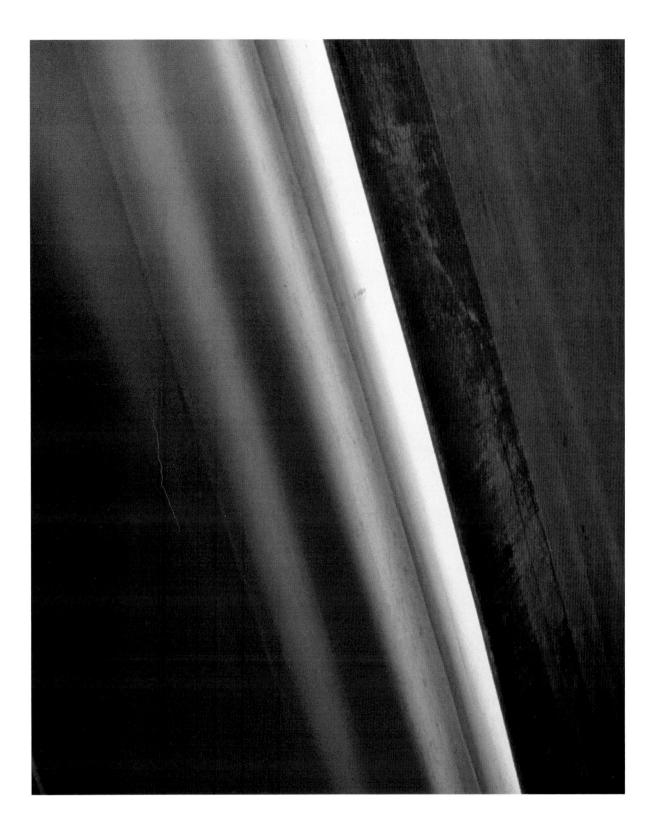

O.T.
80 x 65 cm
1990

O.T.
80 x 65 cm
1991

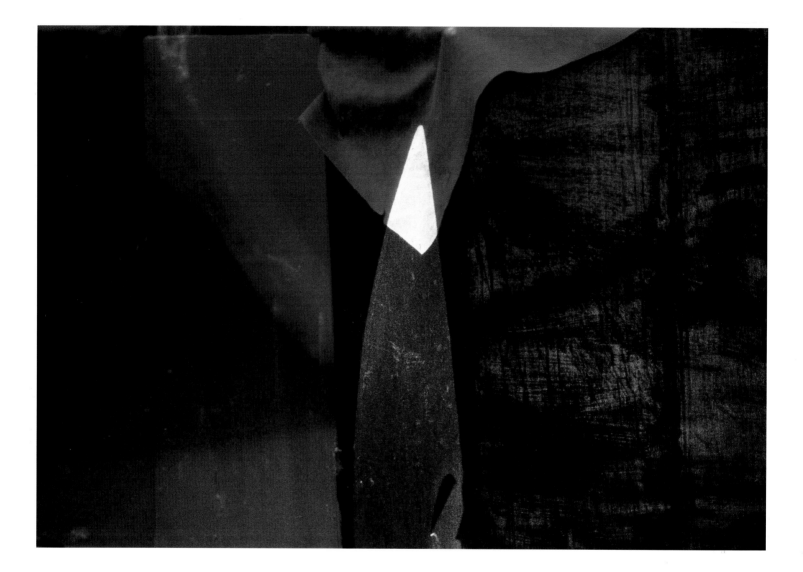

O.T.
80 x 120 cm
1991

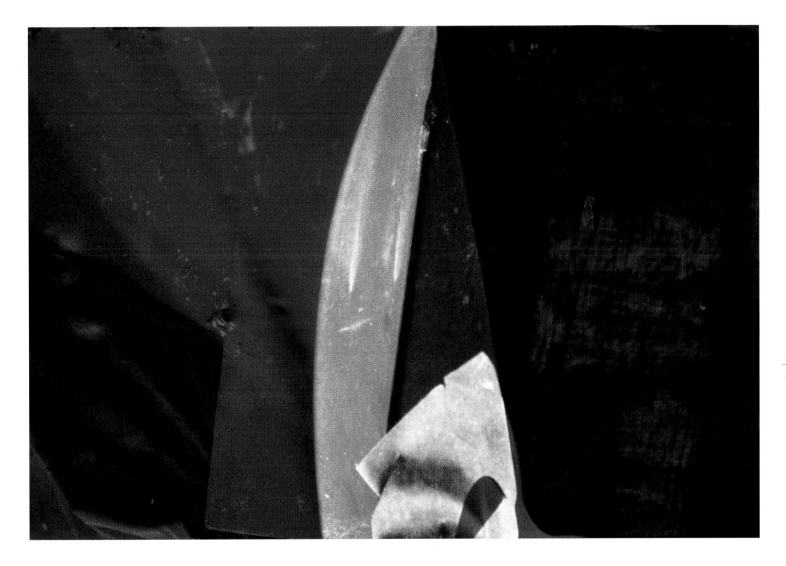

O.T.
80 x 120 cm
1991

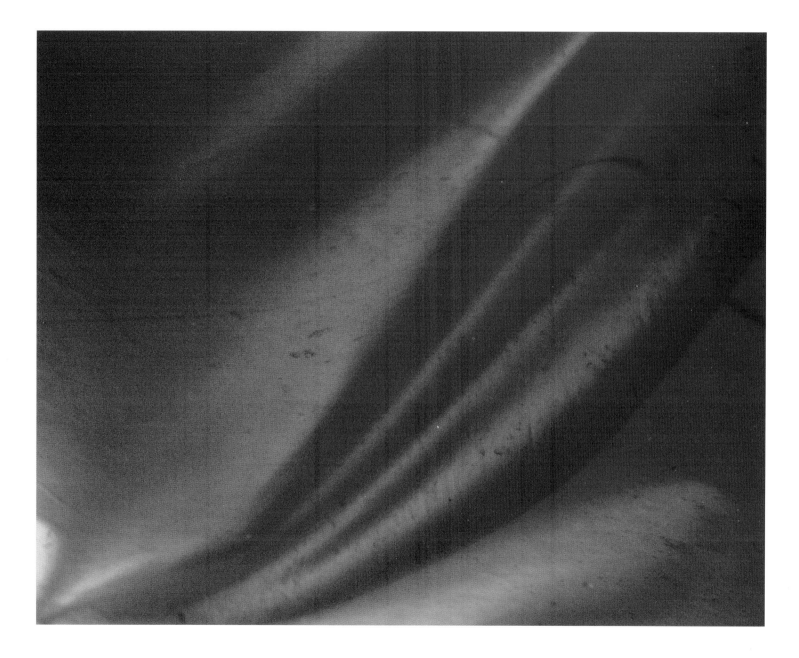

O.T.
110 x 160 cm
1995

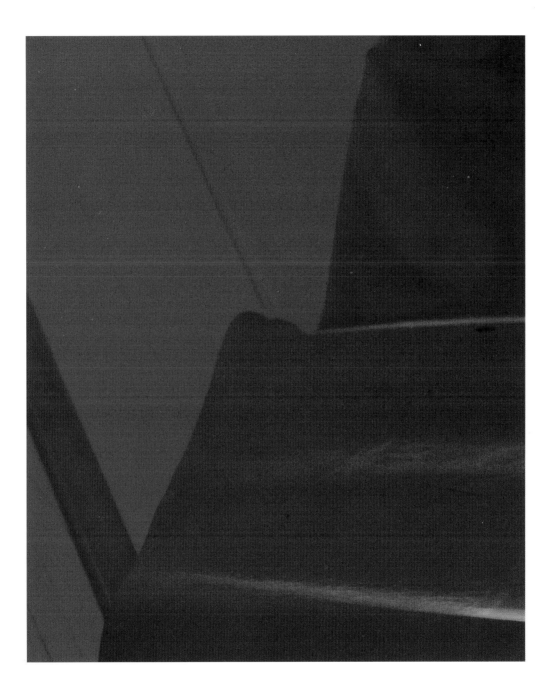

O.T.
80 x 65 cm
1991

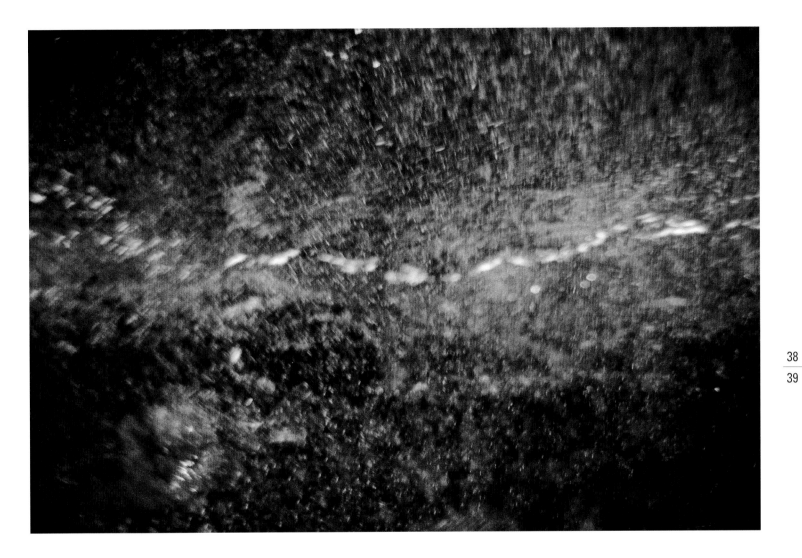

O.T.
110 x 160 cm
1993

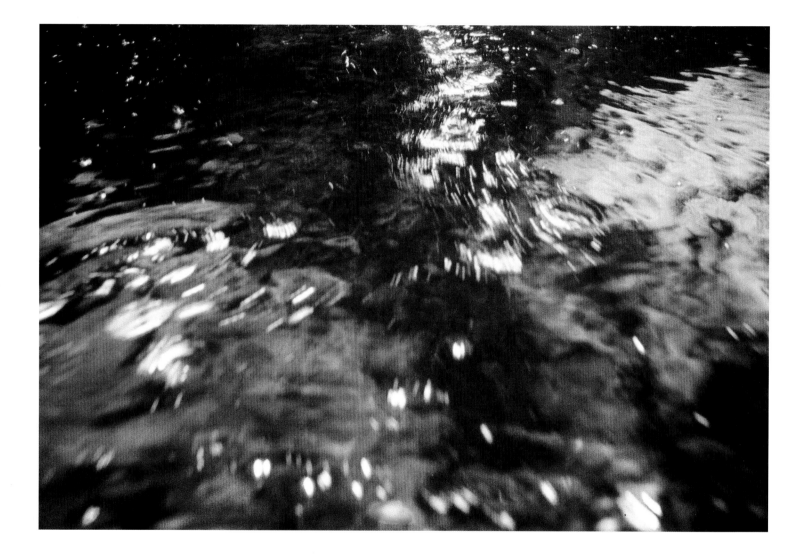

MONACO I.
125 x 185,5 cm
1996

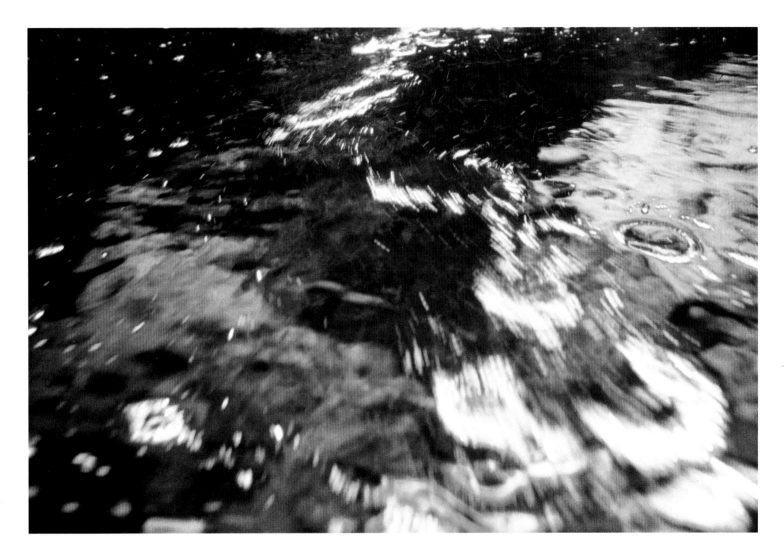

MONACO II.
125 x 185,5 cm
1996

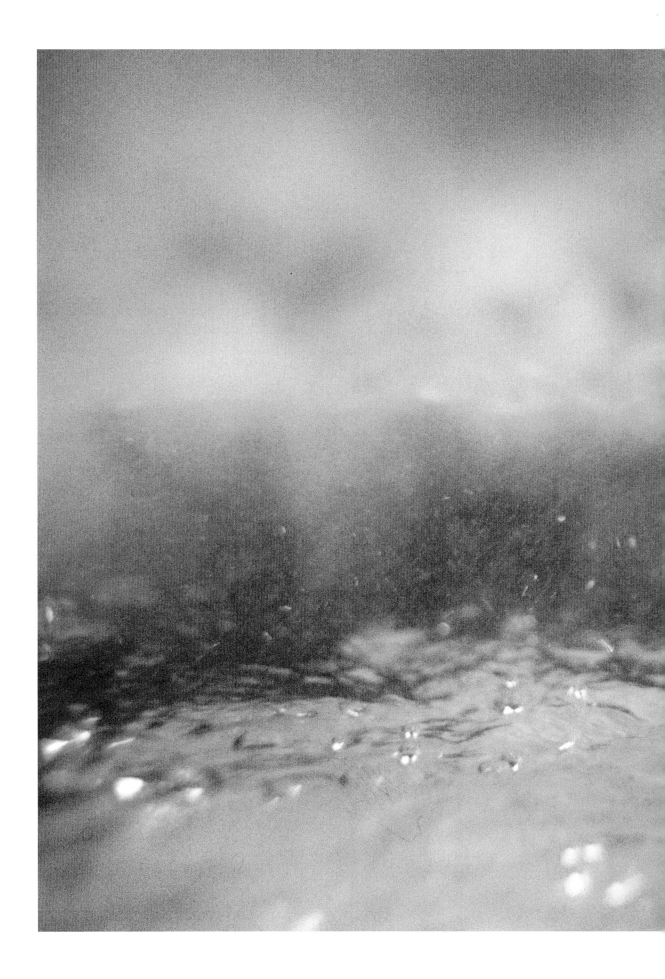

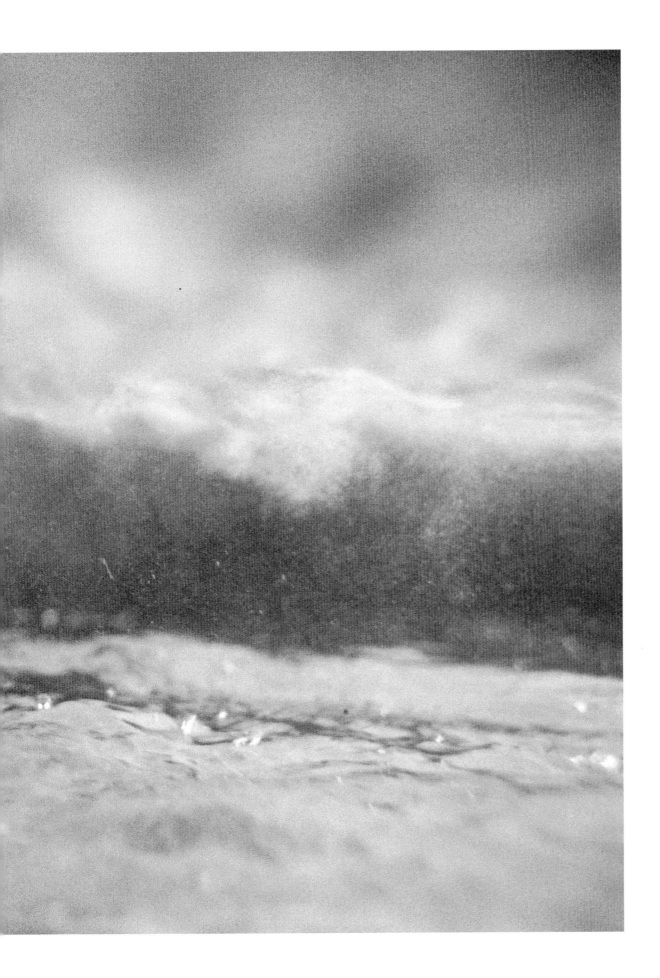

O.T.
125 x 185 cm
1993

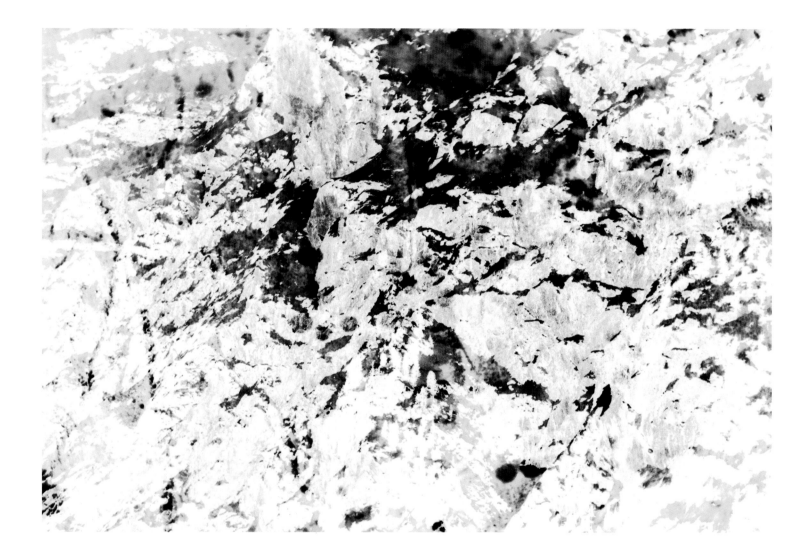

SILS II.
80 x 120 cm
1996

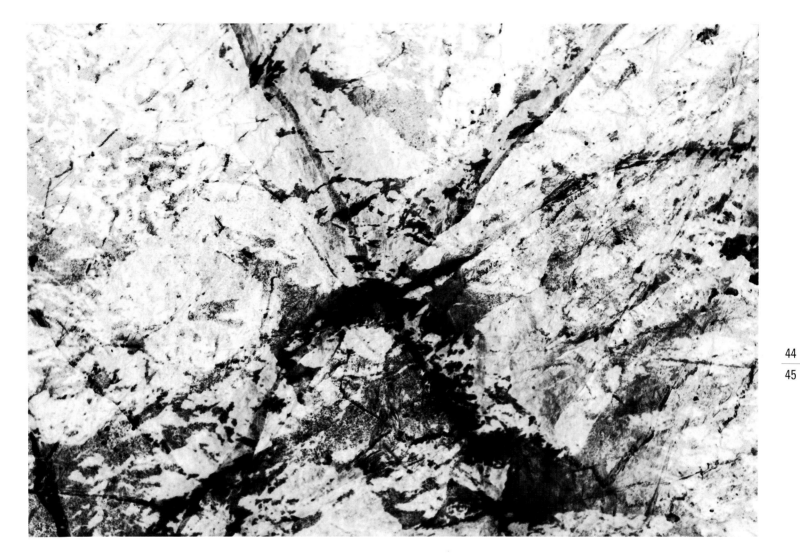

SILS I.
80 x 120 cm
1996

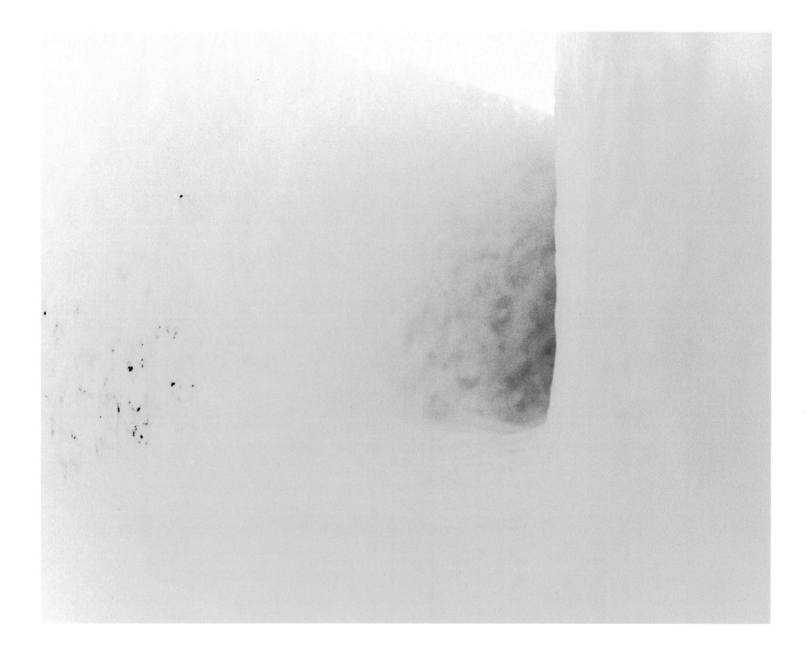

O.T.
65 x 80 cm
1995

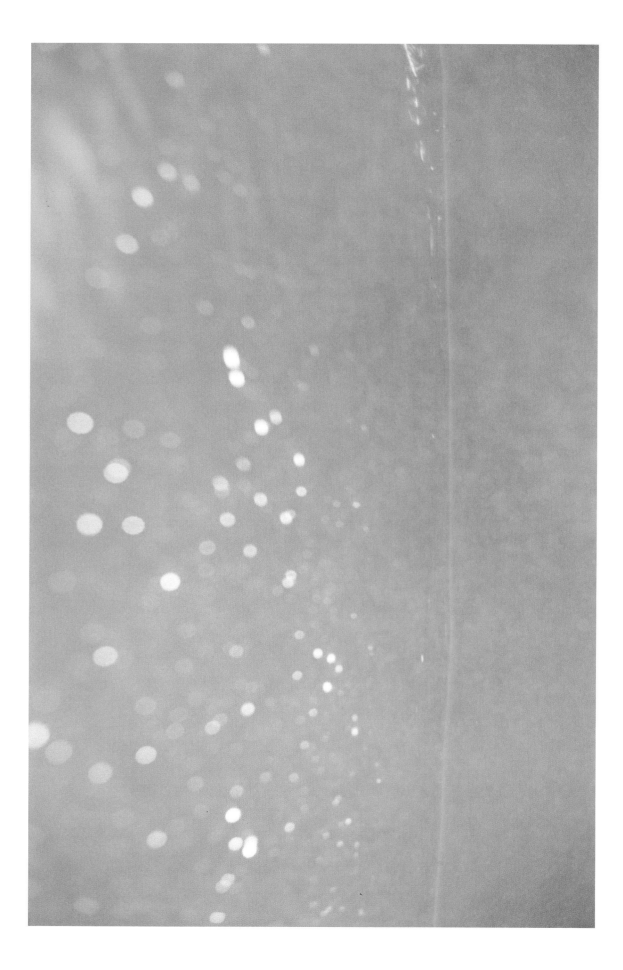

O.T.
160 x 110 cm
1996

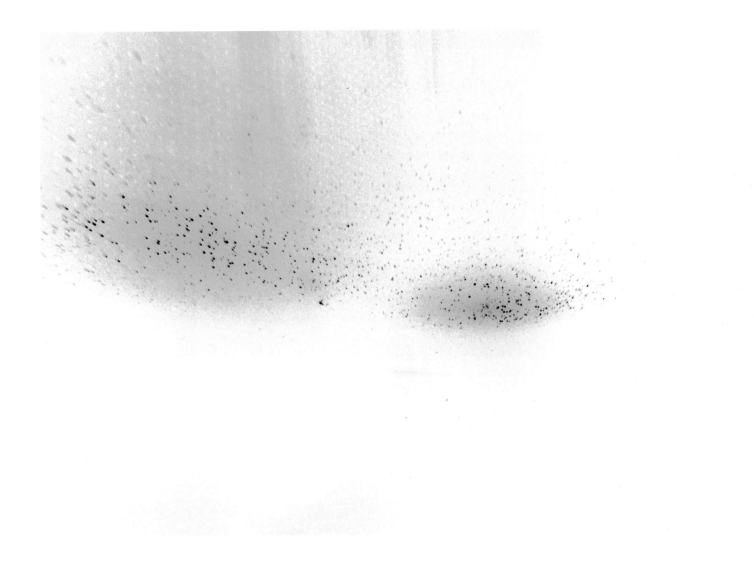

O.T.
125 x 185 cm
1996

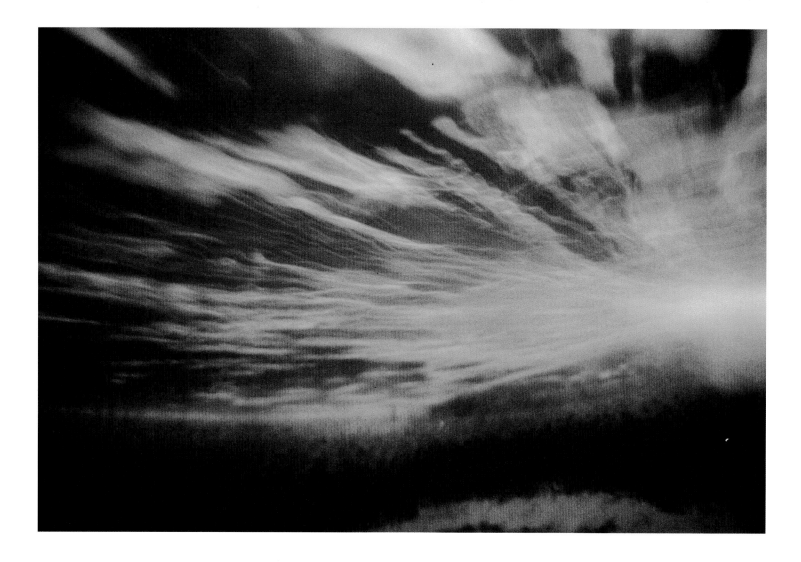

LOFOTEN
125 x 185 cm
1996

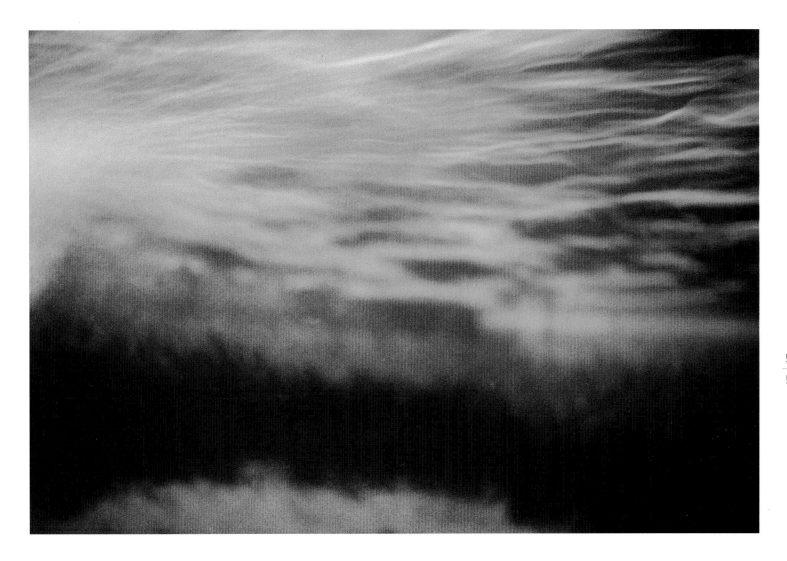

LOFOTEN
125 x 185 cm
1996

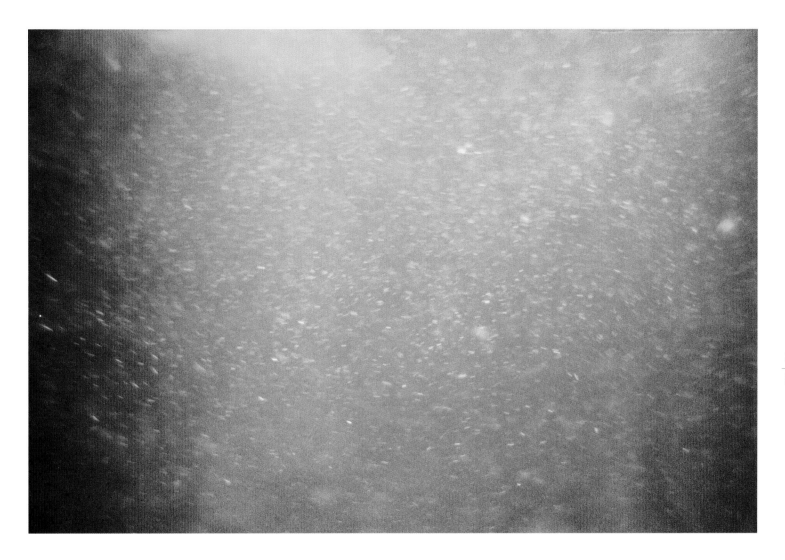

O.T.
110 x 160 cm
1996

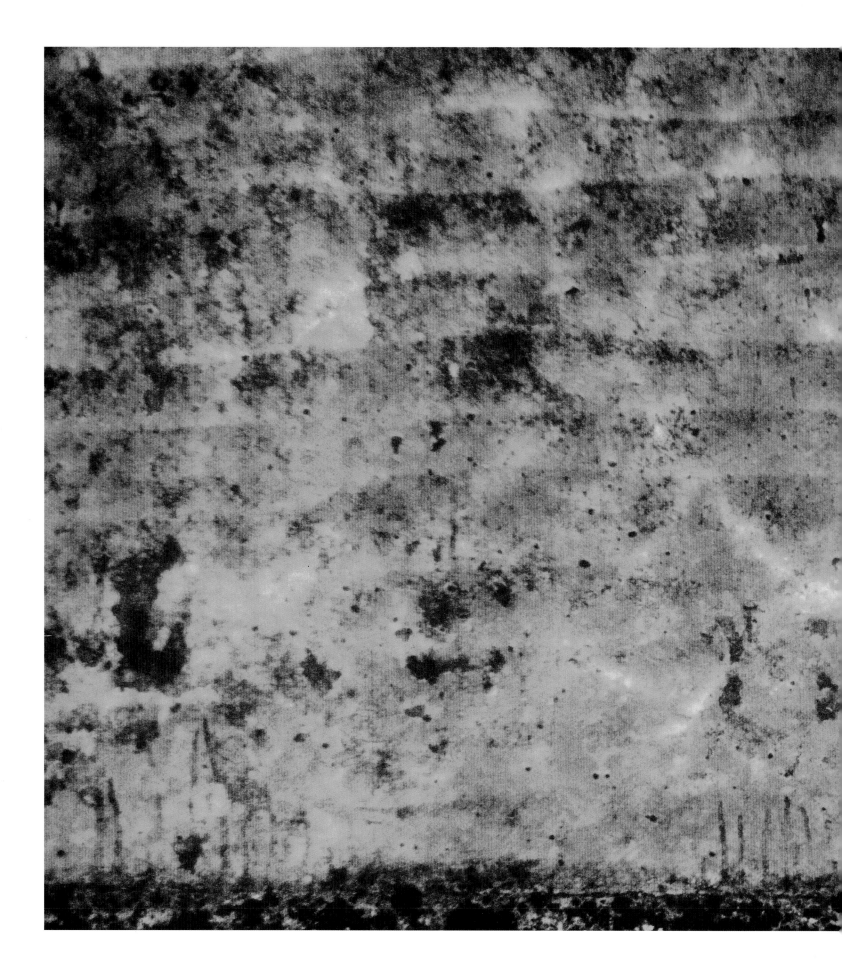

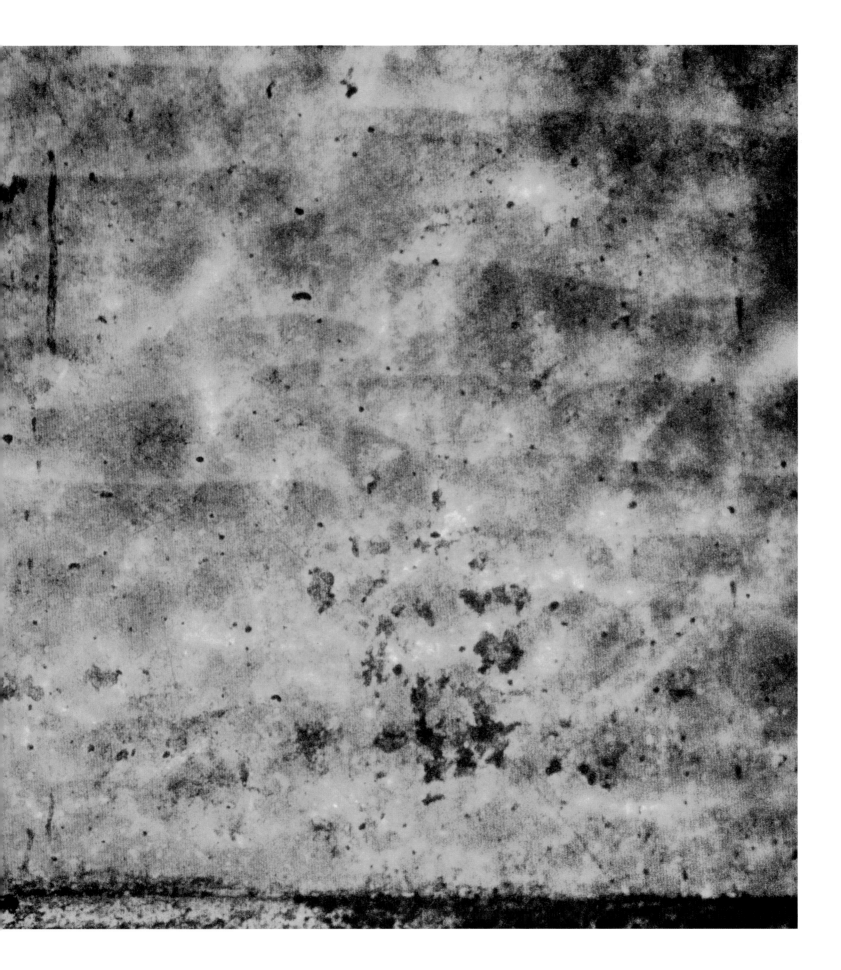

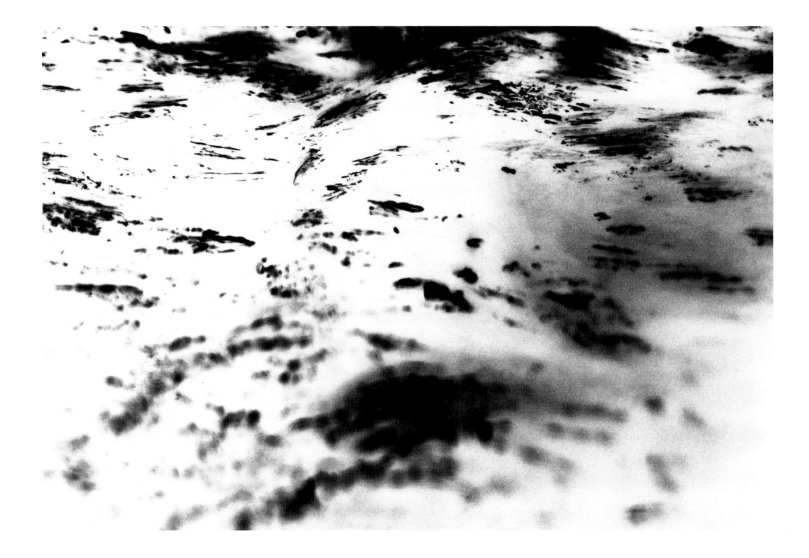

O.T.
110 x 200 cm
1996

O.T.
41 x 60 cm
1995

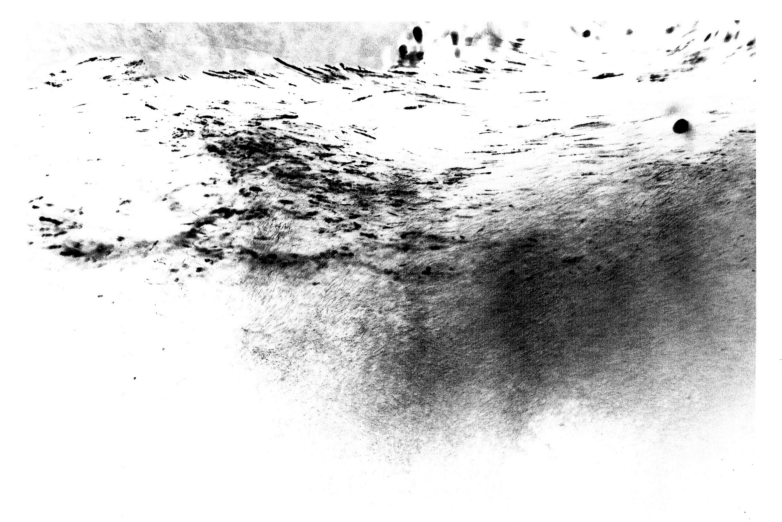

O.T.
41 x 60 cm
1995

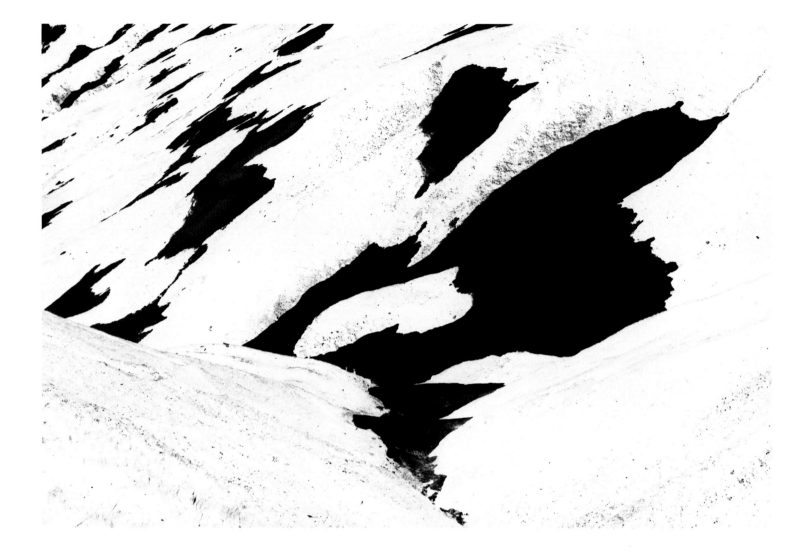

FURKA II.
125 x 185 cm
1993/95

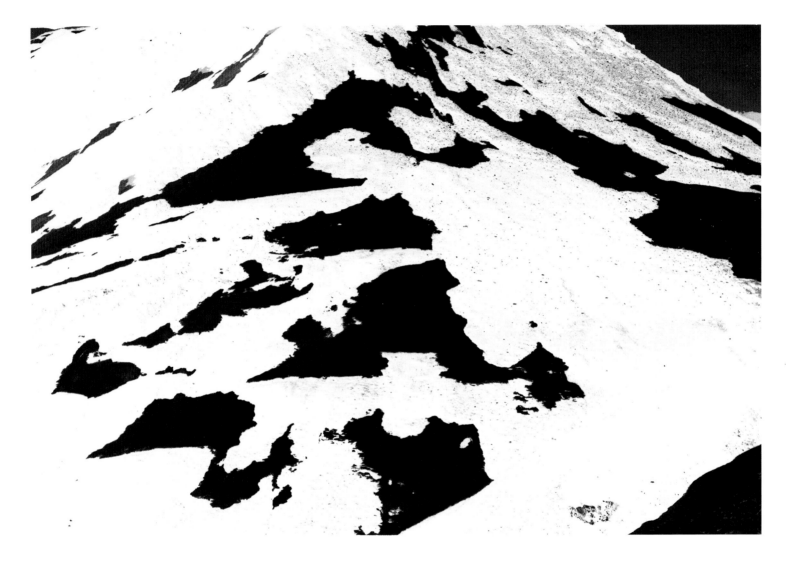

FURKA III.
125 x 185 cm
1993/95

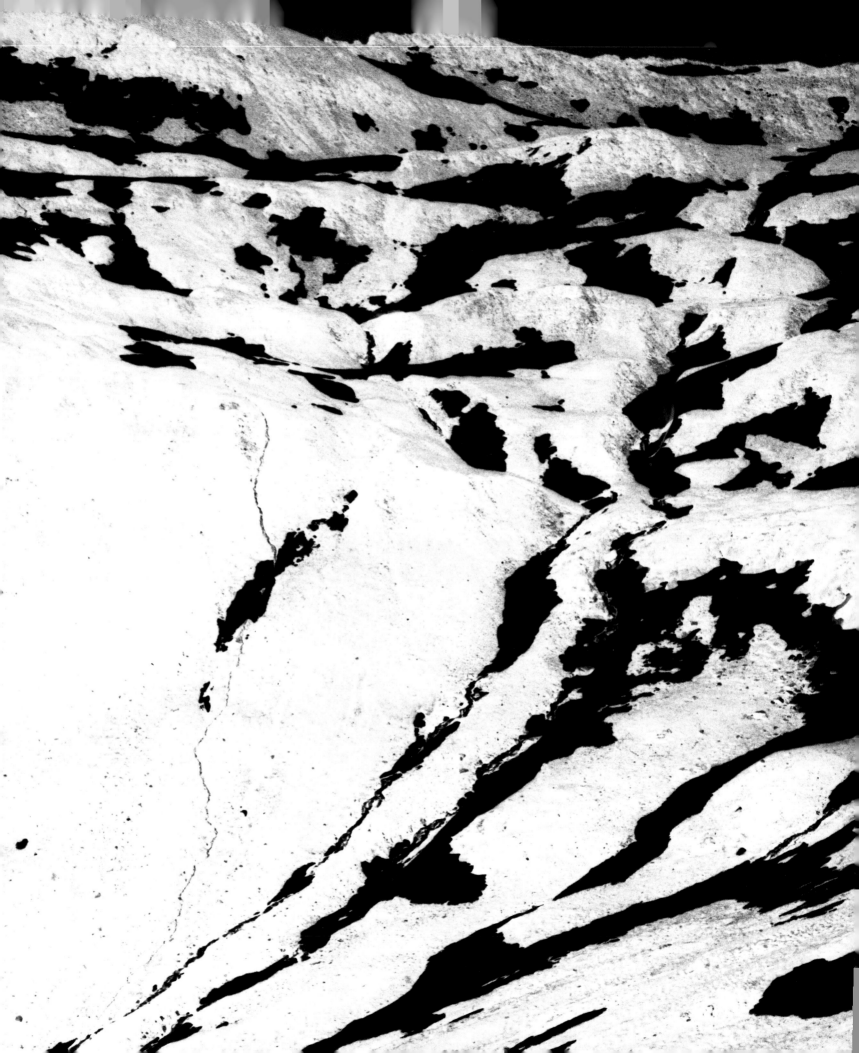

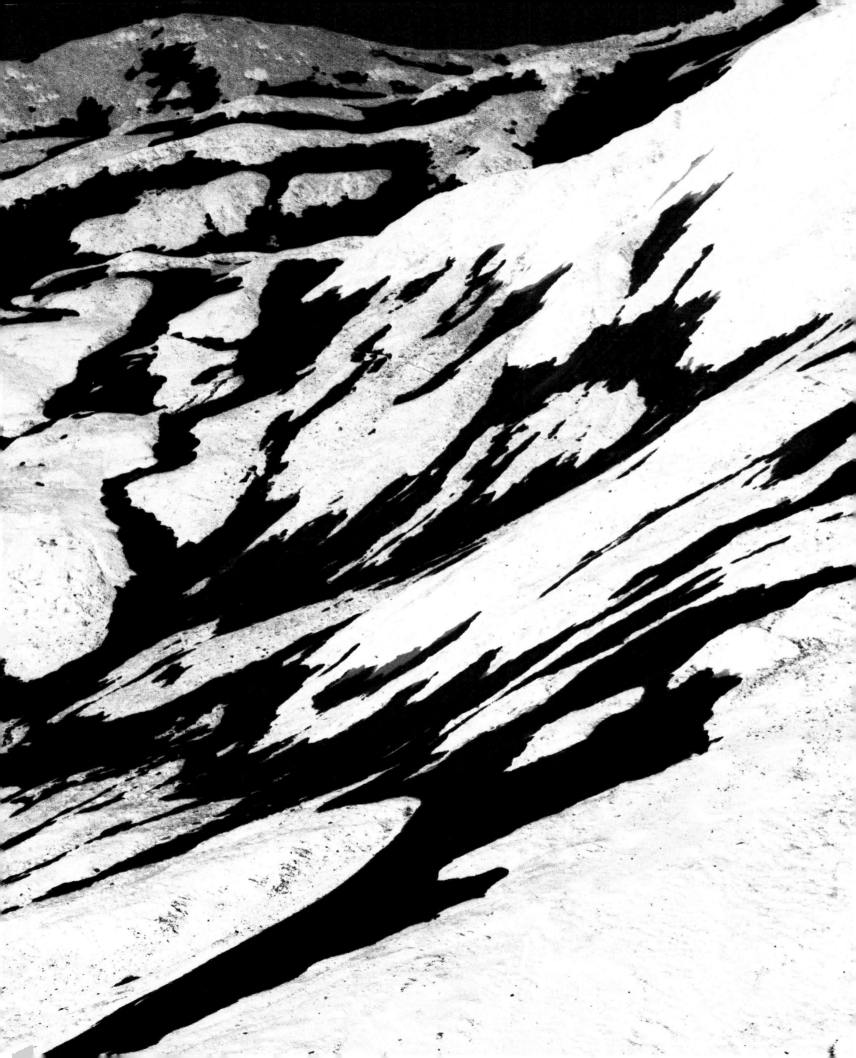

◁ **FURKA I.**

125 x 185 cm

1993/95

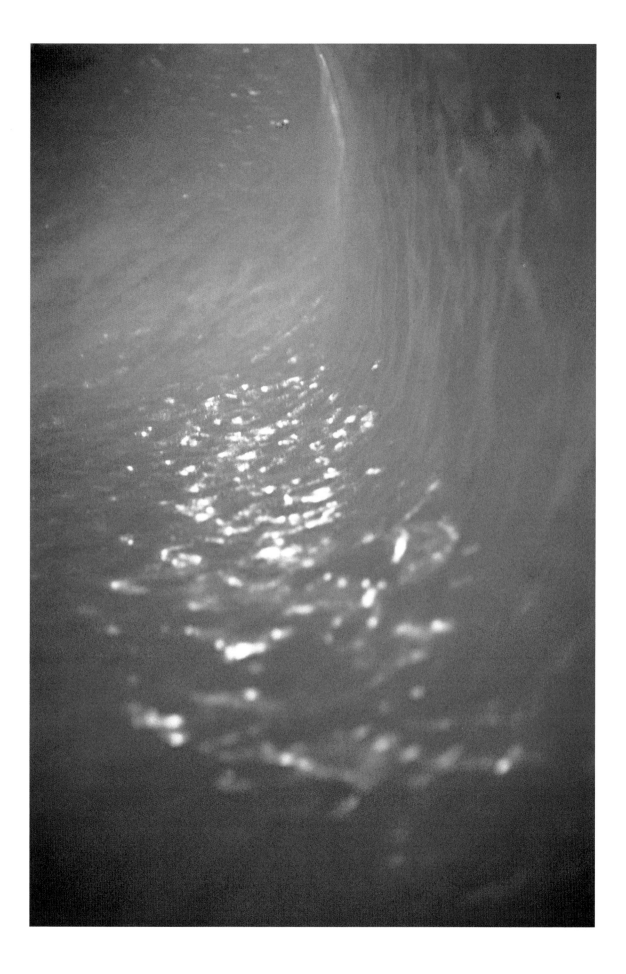

RHONE II.
120 x 80 cm
1995

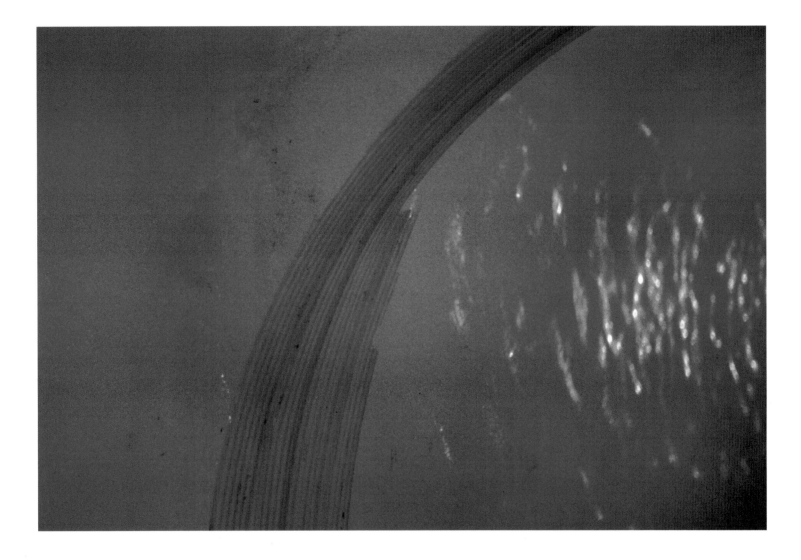

O.T.
108 x 160 cm
1995

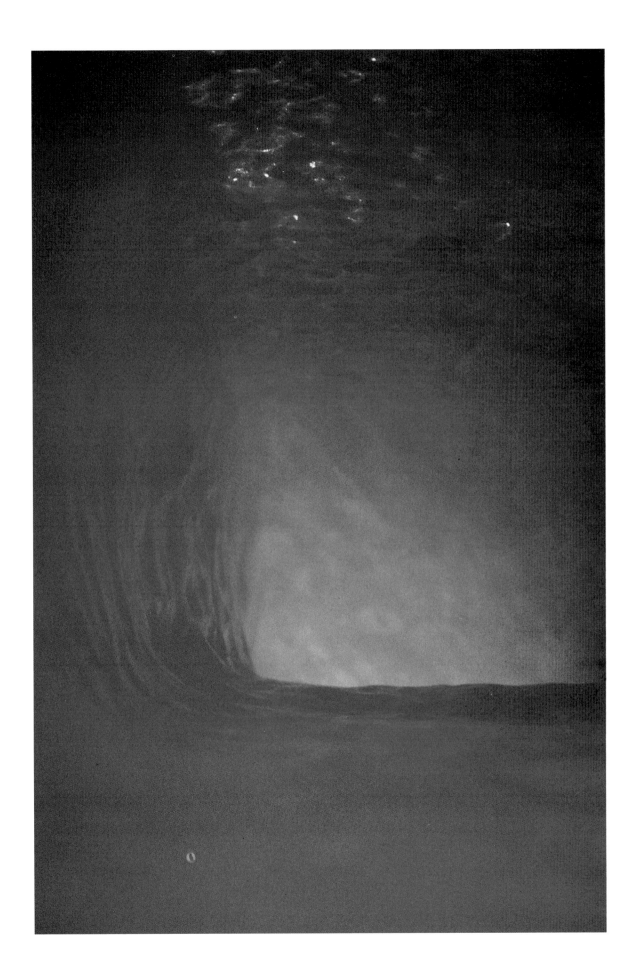

RHONE I.
120 x 80 cm
1995

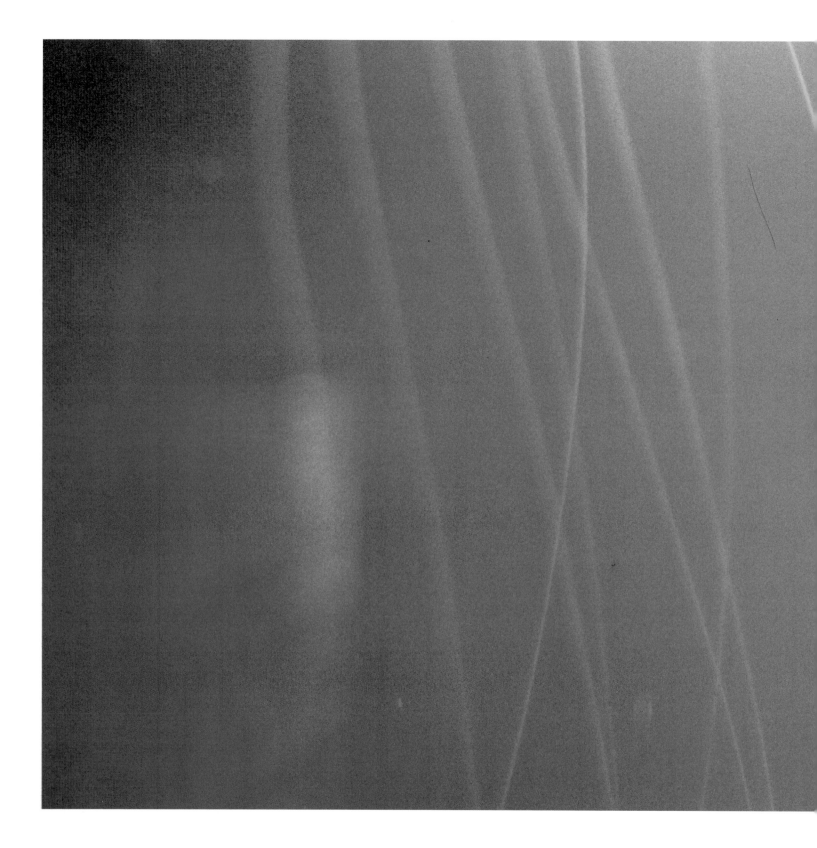

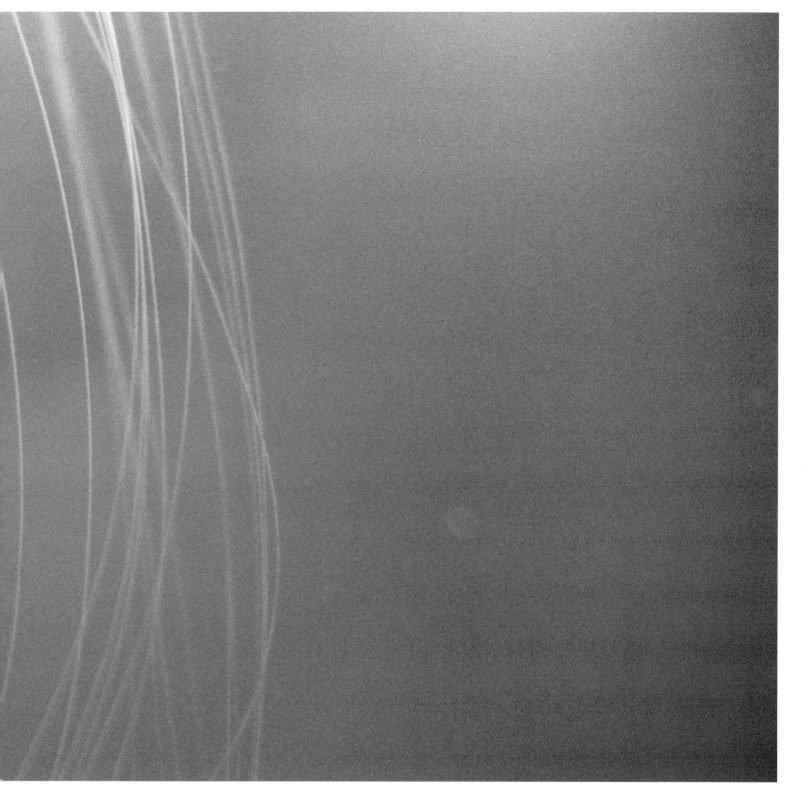

NORDLICHT II.
125 x 241 cm
1995

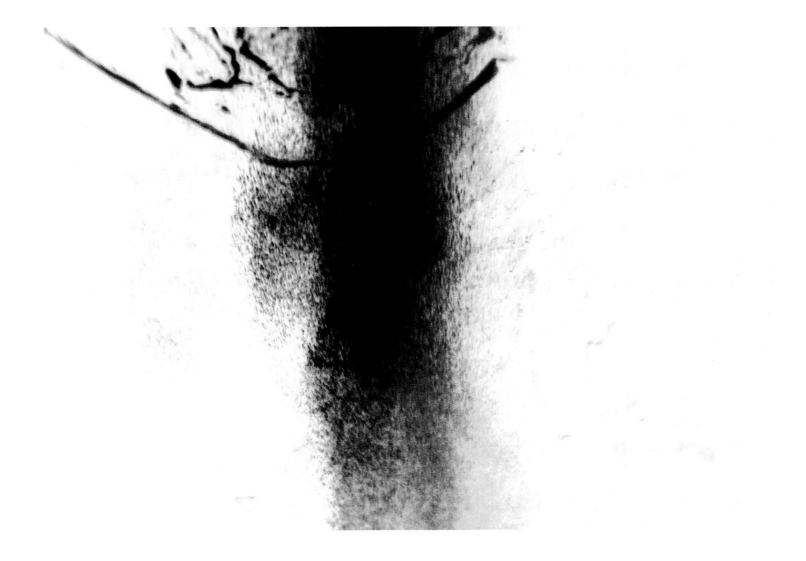

O.T.
41 x 60 cm
1995

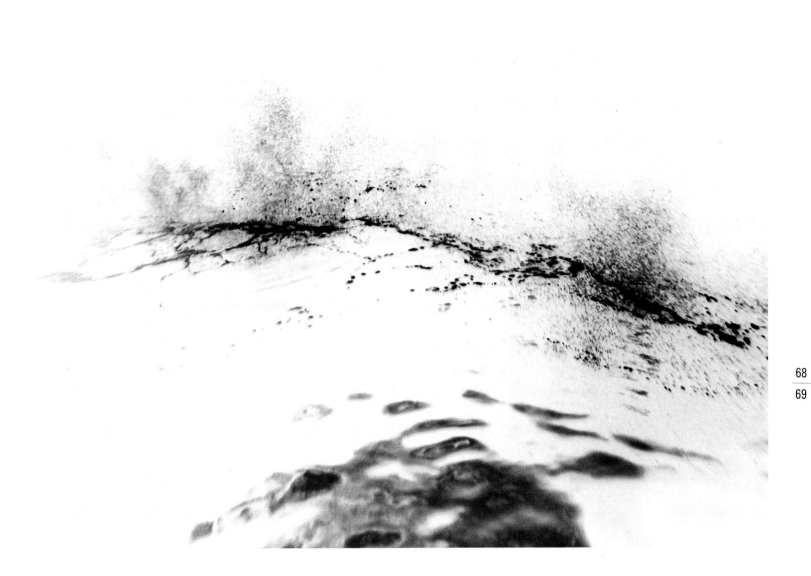

O.T.
80 x 120 cm
1996

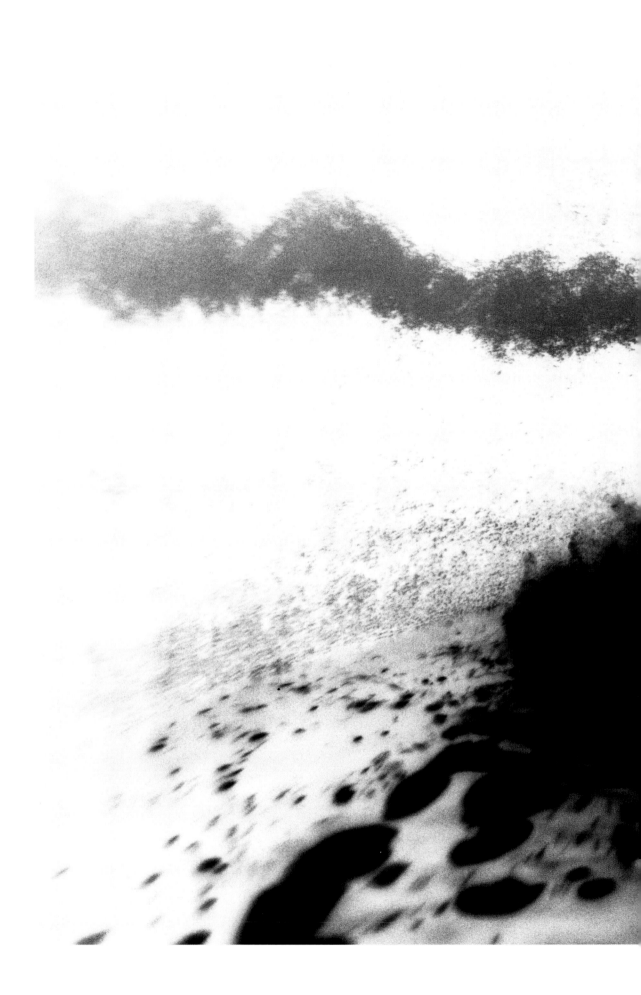

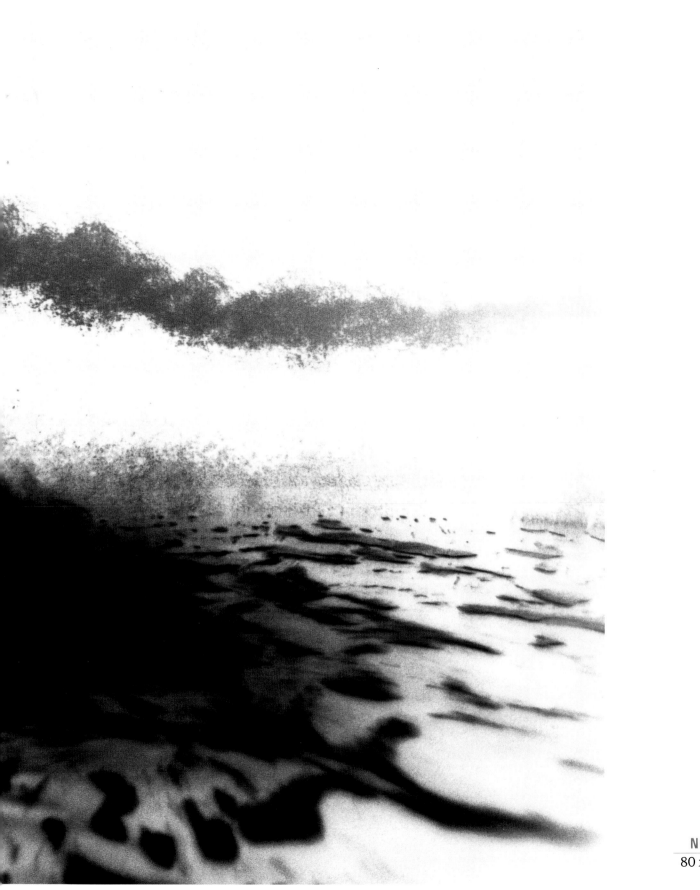

NORDEN
80 x 120 cm
1995

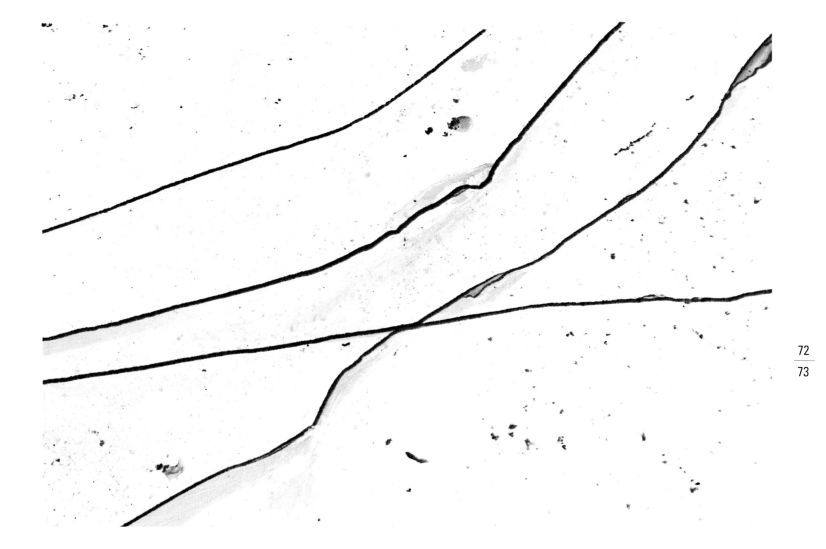

O.T.
24 x 36 cm
1996

O.T.
24 x 36 cm
1996

O.T.
24 x 36 cm
1996

O.T.
110 x 140 cm
1994

O.T.
24 x 36 cm
1995

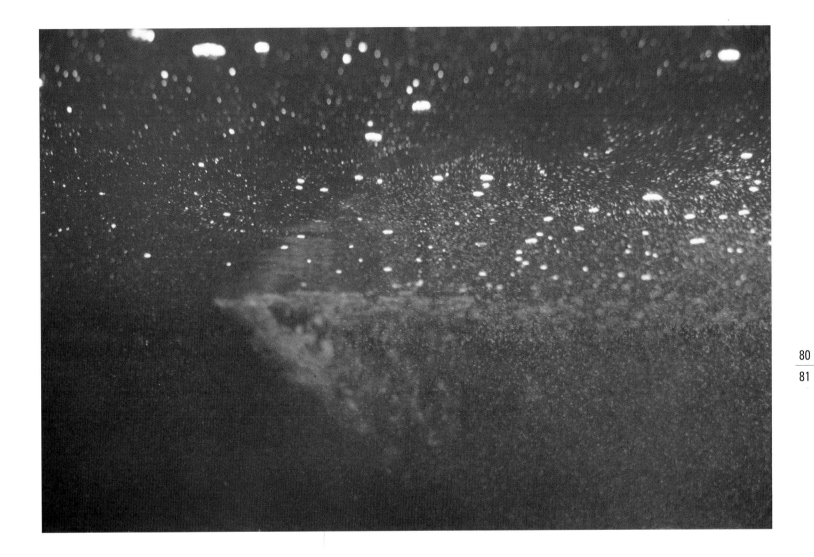

O.T.
80 x 120 cm
1994

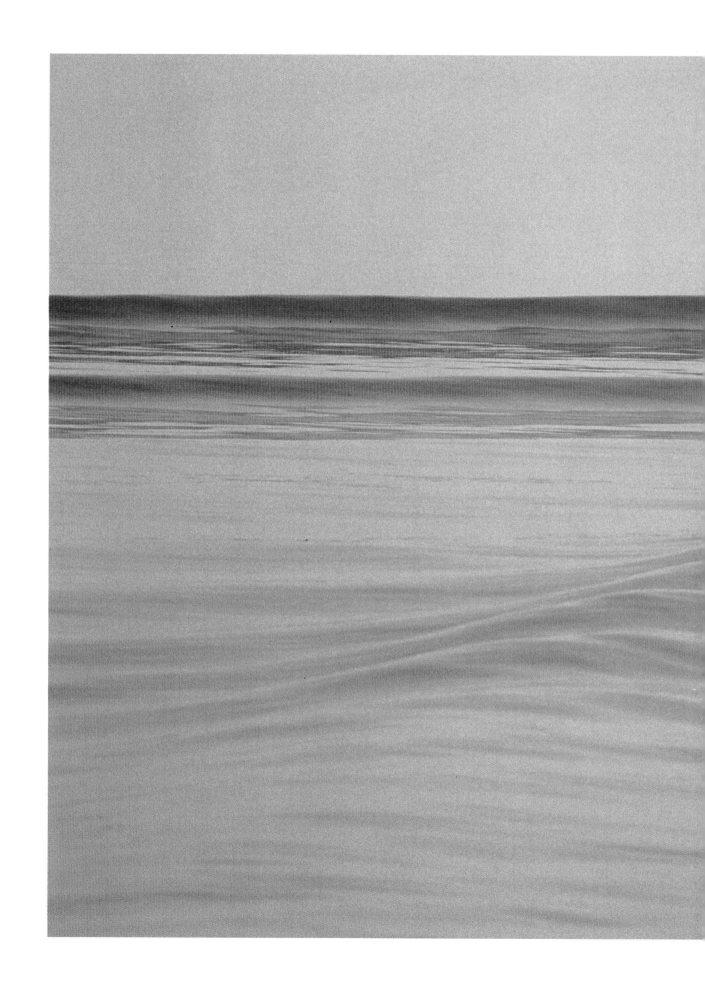

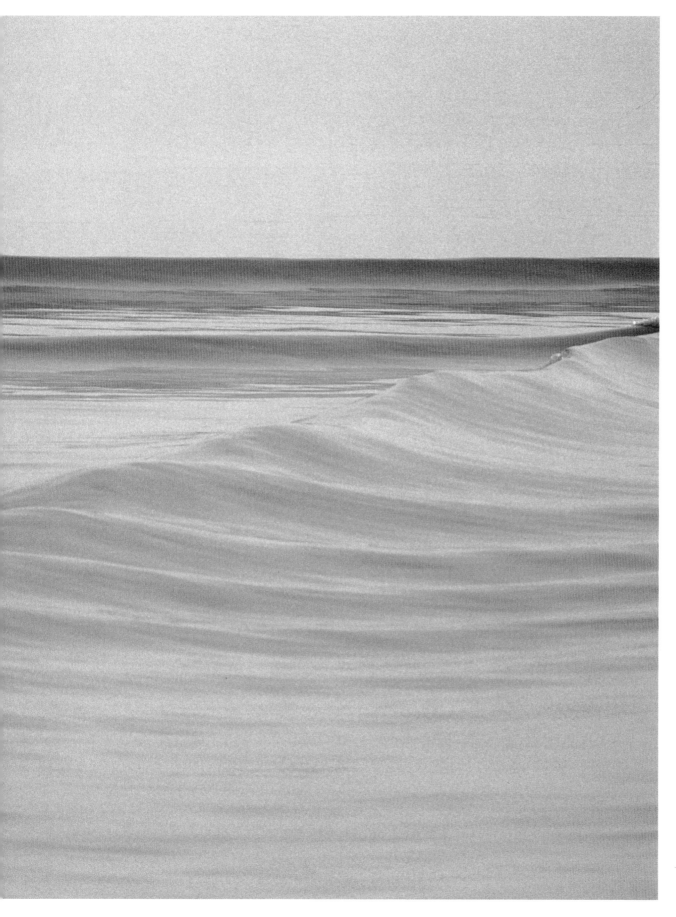

O.T.
110 x 160 cm
1993

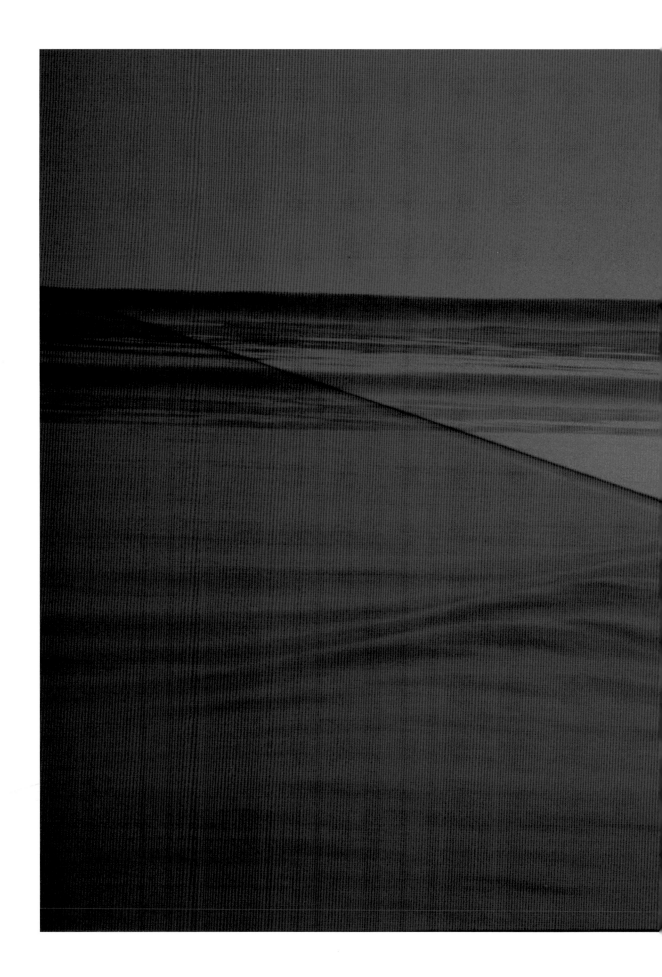

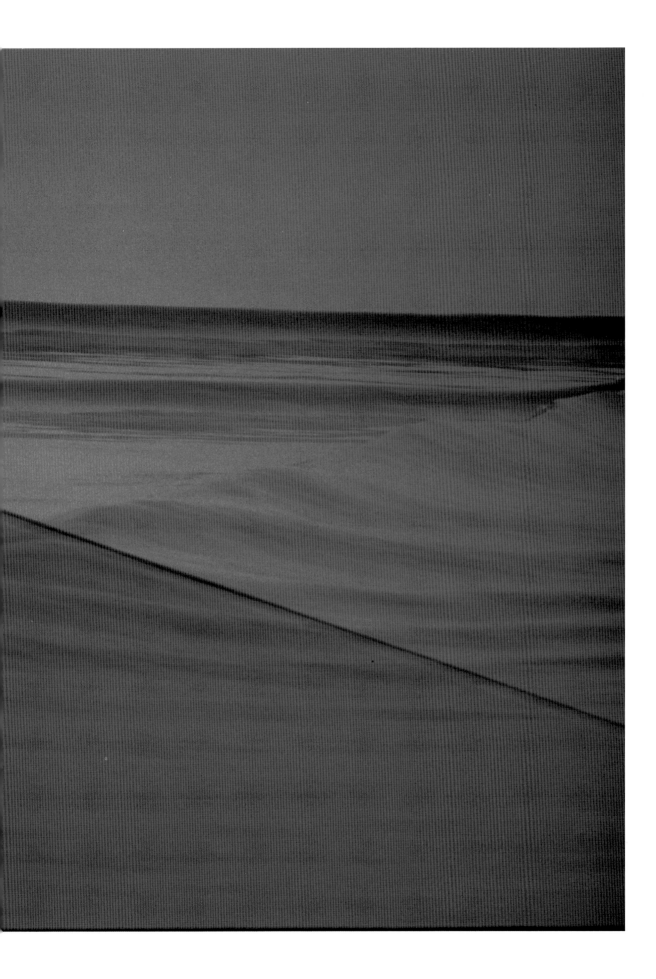

O.T.
110 x 160 cm
1995

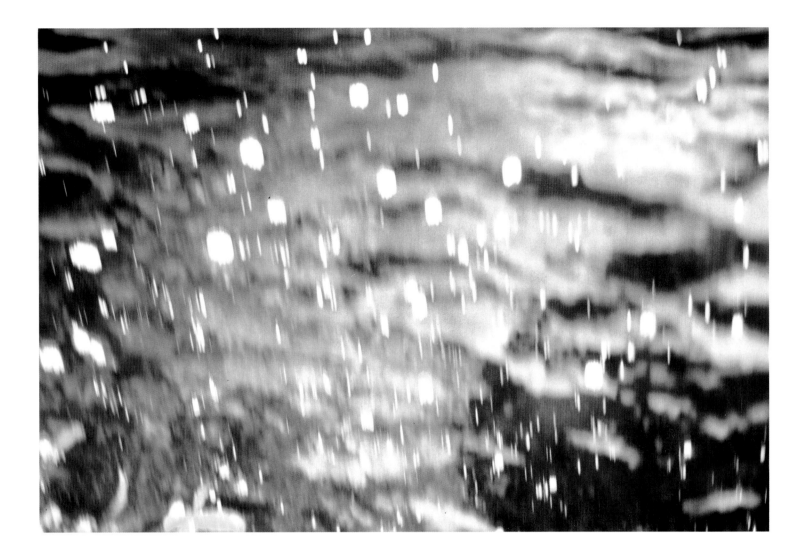

O.T.
41 x 60 cm
1995

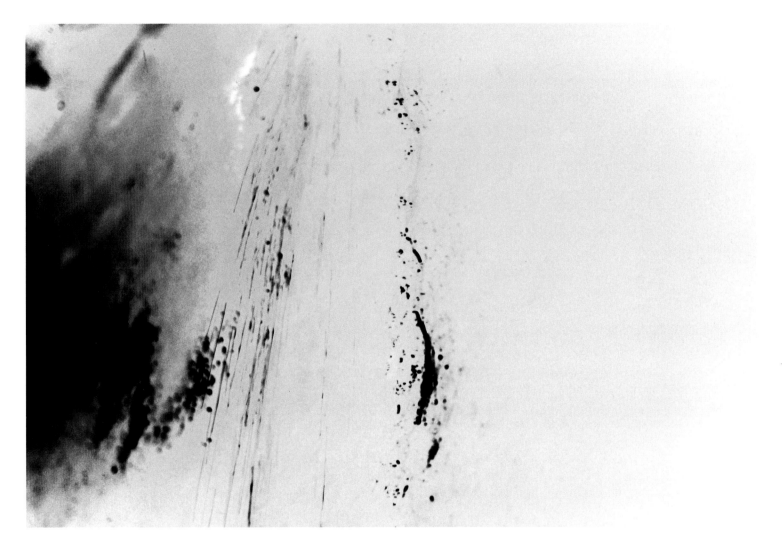

O.T.
24 x 36 cm
1995

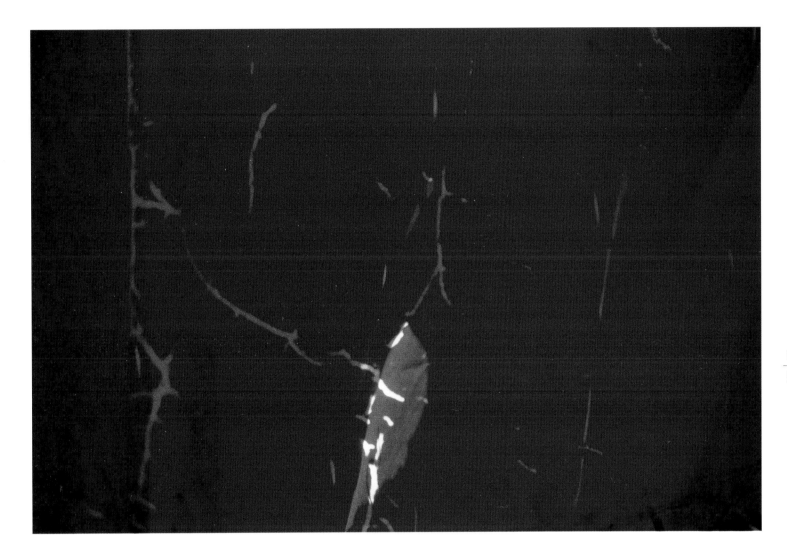

O.T.
109,5 x 160 cm
1990/94

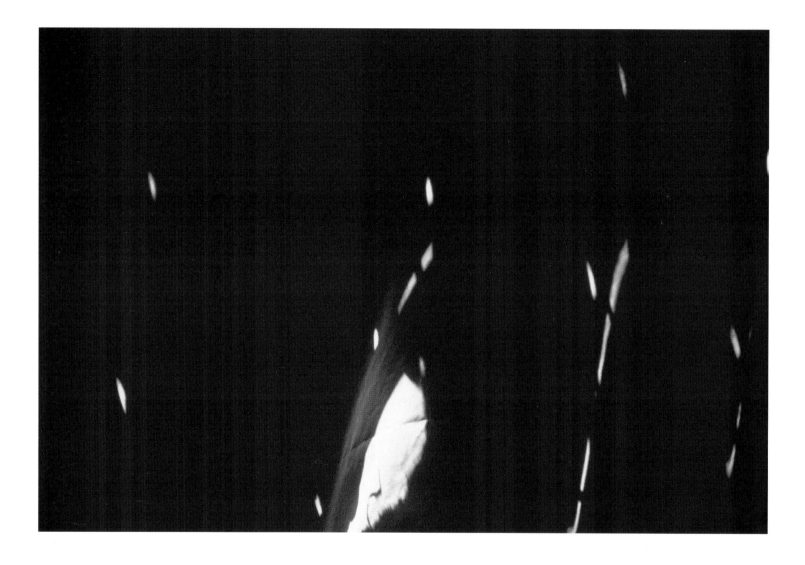

O.T.
110 x 160 cm
1990/94

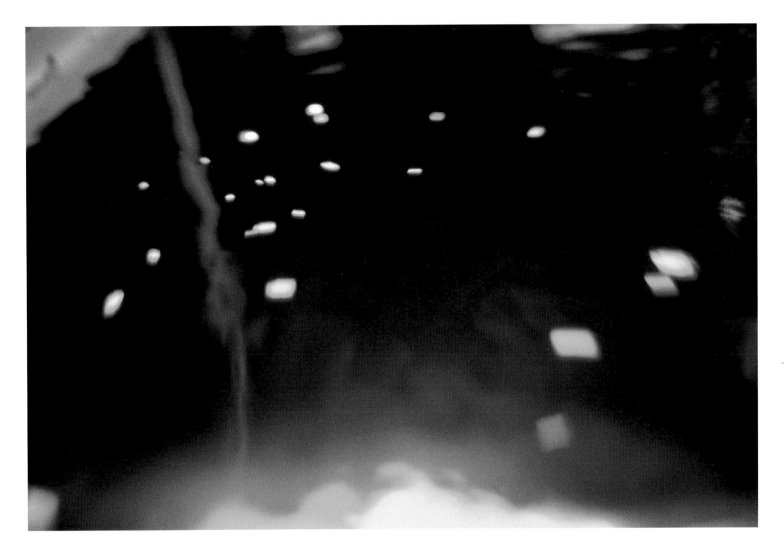

O.T.
106 x 160 cm
1995

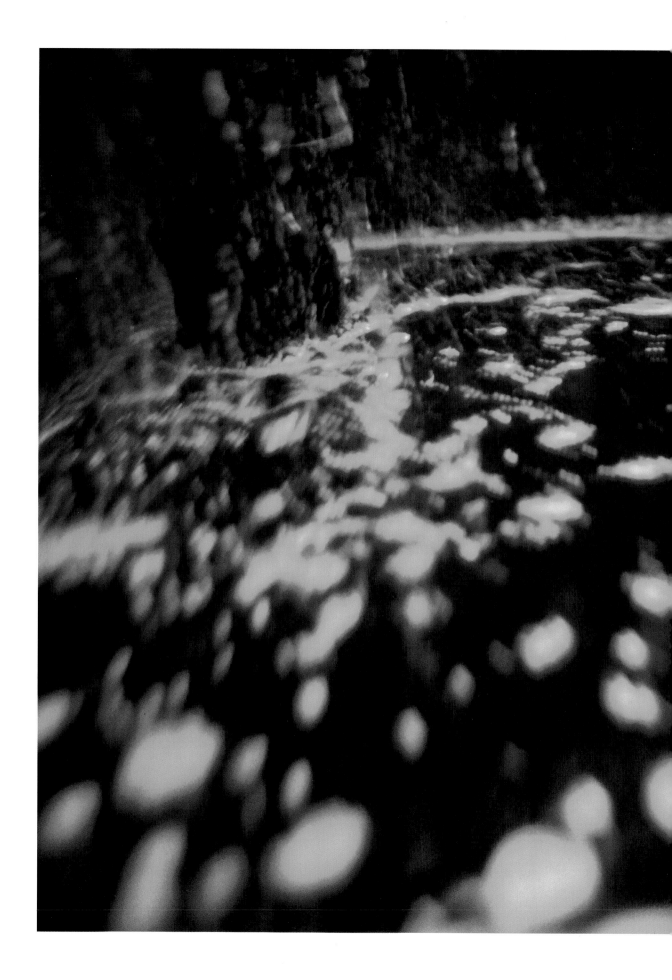

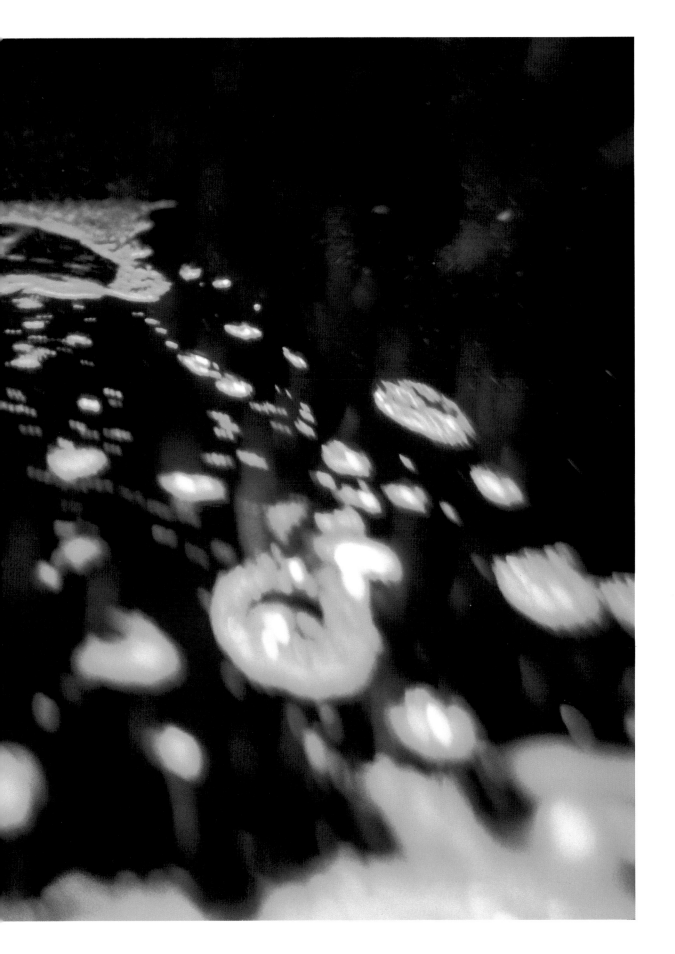

O.T.
125 x 185 cm
1995

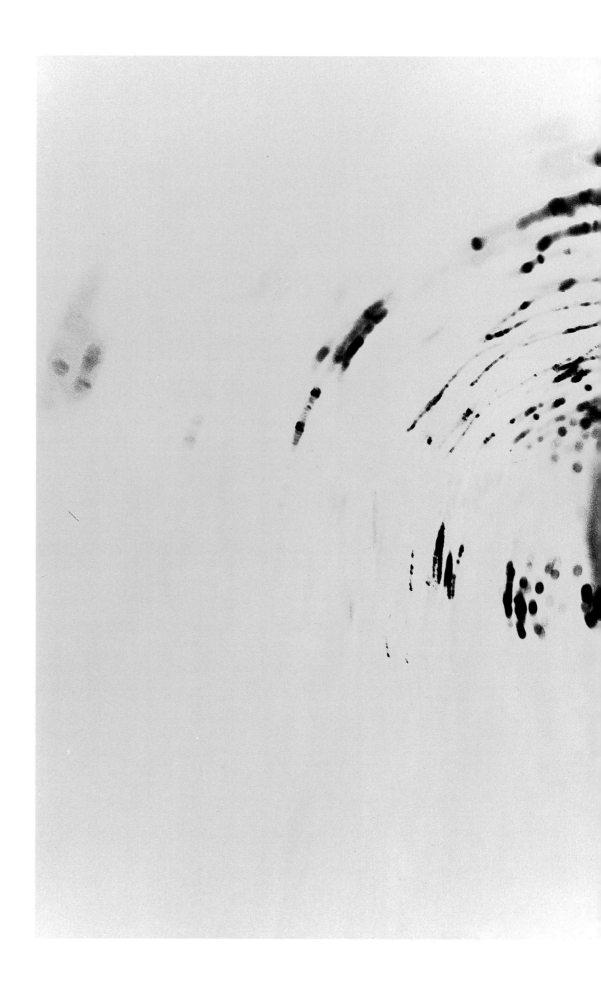

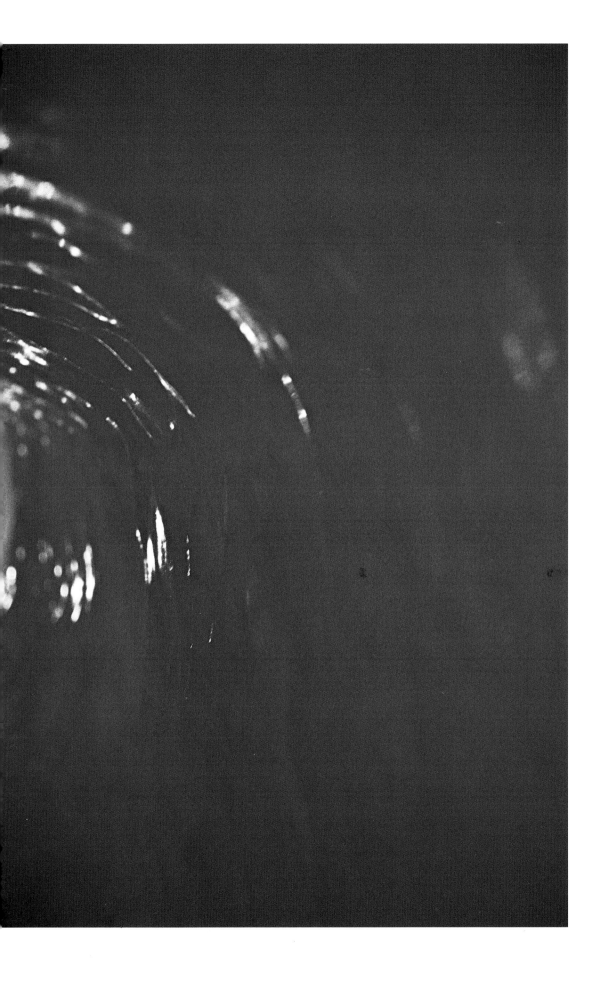

O.T.
101 x 139 cm
1996

APPENDIX

Conversation with A.T. Schaefer
Biography

THE MOTIF IS THE MEDIUM ITSELF

A.T. Schaefer in conversation with Claudia Gabriele Philipp, January 25th, 1996

C. G. Philipp: Color plays an important role in your photographic works right from the start. What can we anticipate in your latest collection of work?

A.T. Schaefer: The place of color is the main point of concern in the pictures on show here – the places all exist. The colors haven't been made synthetically. That would be a different concept. I "suck" the color out of the place I am working from, like this blue, for example. It is located in a specific place, and there is no need at all for me to name it, but it actually exists. I often work with a complementary color, which exists only because the other exists. One place of color makes it possible to create a new place of color. It is precisely this idea that is summarized in the large blue-and-yellow picture and is a fundamental part of its genesis. I also see places of color in a chronological sense. This moment in the history of art, one that I consider extremely important, was addressed – long before Albert Einstein's time – by Richard Wagner in *Parsifal:* "Time here turns into space". Thus not only film, but also the still, unmoving medium of photography can document time. When I open a shutter,

and expose the film to light, a trace forms. It is exactly this direct trace of time that becomes visible.

C. G. P.: You have addressed many different points, and outlined all your ideas. The world of objects is the starting point for your work. Yet you also set a process of abstraction in motion, making material things visible. You are not a "Generative" photographer in the original sense. That movement was founded in 1968 by Gottfried Jäger together with Kilian Breier, Pierre Cordier and Hein Gravenhorst. But from a contemporary point of view, your system of reversing colors does strike me as bearing a definite relationship to their theories. The conscious, intentional use of physical, chemical processes in the creation of your works has more in common with the basic concepts of the Generatives than might at first meet the eye.

A.T. S.: I have never consciously worked in this direction, actually. My basic idea derives from a very sensual component.

C. G. P.: The crucial question I keep asking myself is: what makes a painter turn to photography? It must have

had something to do with your training in art. You studied painting and design. And then there are your three-dimensional works that contain photographic elements. These might be regarded as a kind of photo-sculpture.

A.T. S.: That all has to do with my wide range of interests. It is no coincidence that I originally wanted to become a conductor before I eventually turned to art.

C. G. P. Both music and color resonate. We speak of musical tones, and color tones as well.

A.T. S.: The title of an exhibition in Stuttgart – *The Sound of Pictures* put that into words. For me this theme is always a hidden presence. I am always interested in abstraction, in the concept of color, not the question of what medium has been used. That is secondary, except of course in the actual execution of the work. During my studies I used all kinds of different media. I was lucky in that the School of Applied Arts in Hanover in those days offered a course which encompassed architecture, design, and painting. What stayed with me was the concept of the *Gesamtkunstwerk* (total work of art), as Harald Szeemann has expressed it. Aside from that, my teacher at the *Werkkunstschule* was Umbo (Otto Umbehr) although at that time I did not actually realize

who he was. The point is that there was someone there back then who made us aware of the existence of other media. Because of this, I was aware of photography as a medium by the mid sixties. However, I was never interested in the image depicted, only in the medium itself, a means by which a trace of light could be caught directly on the photographic plate, and the appearance of light made visible. Then came the reversal, when I realized that light could also be depicted. That's also how the exhibition *Light shines only in the Dark* came about, which took place at the Museum Ludwig in Cologne, in 1991.

C. G. P. You build up and develop further. It is a simple fact that the history of art thrives when things are continuously being reassessed and developed further, that ultimately artists always have new insights to work with. With the development of today's color processes you are able to realize things which Moholy-Nagy could only have dreamt of, things which would not have been possible in his day. History helps me as a historian of photography to grasp and comprehend what you are doing.

A.T. S.: Man Ray is the other historical figure who should be mentioned. He constantly transcended the borders between abstraction and the representational, as when he photographed Meret Oppenheim naked at

a printing press at the same time that he was producing photograms (or rayograms). The question was never asked, why on one hand a nude photo, and on the other something like that. I've always found it stimulating that it is possible to do both. To come back again to Moholy-Nagy, he and other artists developed positions during the 1920s that have remained in obscurity for years. I would like to explore and extend this side of photography for myself. In the past two decades, the Becher School has steered public consciousness along another path.

C. G. P.: Let us stick to your work. In retrospect it shows an amazingly rigorous development. In an enduring creative process you have been occupied for years with the theme of metamorphosis – an interesting phenomenon, especially in photography. Your photographic works were first published in 1983.

A.T. S.: This first exhibition was staged in order to find out what the outside reaction to my work would be.

C. G. P.: The cycle *Opera in Stuttgart* seems slightly anomalous here, as the theme, the "reality" of the world of opera is in the forefront. Normally you do not depict the object. You render something visible – a kind of oscillation, a regular alternation between the abstract and the concrete.

What is the relationship between exterior reality and your ideas? What do you render visible?

A. T. S.: The further I progress in life, the more pictures I make, the less I understand what reality is. A perfect image in the style of the Neue Sachlichkeit, for example, can be substantially less real than a single bubble which leaves only a large white mark behind on my picture. In my own way I am constantly redefining what reality is in a visual sense.

C. G. P.: The famous epistemological question posed by Paul Watzlawick, "How real is reality?" is especially pertinent to photography. Our basic problem in this medium is the "dilemma of representation", the character of the depicted object is always hidden somewhere within the work (like the devil in the nuts and bolts) and is naturally something the public enjoys seeing. Perhaps this is one reason for the high esteem in which the Becher School is held, because there is apparently so much to recognize in their pictures.

A.T. S.: It is basically a matter of a poetic, a musical element. The cuckoo's call or the song of the nightingale can be imitated on the flute – a matter of mere reproduction. Yet the very essence of music is counter to this, kindling as it must feelings and moods, setting in mo-

tion vibrations which I perceive aurally. Physically, they may be seen as waves – just like light. The point being the theme in its own right. If I were painting, it would be for painting's sake. Therefore, the theme of photography is photography itself and not the depiction of things. Photography should be developed along other lines than what I often love and admire as its power of depiction. The inner theme of photography is of far greater significance; that of the photographer as a drawer and painter of light.

C. G. P.: In an analogy to the painter, Moholy-Nagy described himself as a *Lichtner* – or "lighter".

A.T. S.: That term is new to me! I'd be glad to accept it as an honorary title.

C. G. P.: What role do forms and structures play in your work?

A.T. S.: Of course, they cannot be separated from color. I enjoy a marginal interest in the great experiment of monochrome pictures. Stillness is also one of my themes. I could never imagine my large red pictures full of small shapes and forms. This gentle blue picture here – the gentleness is related to depth and even to the unfathomable – also comprises in a formal sense this blurred quality that seeks depth. It occupies the same level

of abstraction as the sharp focus of these white patches here.

C. G. P.: Blue conveys a more calming effect, whereas red is aggressive or active – at least according to traditional color psychology.

A.T. S.: Depending on your mood. Color is created in the lab, that is, if you see the "laboratory" not merely as a place to develop film but in the sense of laboring, experimenting. If I had lived in the nineteenth century, and had had the chance, I would like to have been a private scholar. That's how I see my photography – as research into the visual possibilities.

C. G. P.: What part do your picture surfaces play – the actual surface of the print or the transparency on the slide table? Have you ever considered the possibility of large format color transparencies? Doesn't the "Place of color" also specify the place of the recipient in very exact terms? You refer him ultimately back to the picture surface. You never use a transparent picture as the end product. This is a significant decision to take.

A.T. S.: I have not experimented much with transparencies. This stage of photography is the next thing to the monitor or TV screen. It is lit from behind, and thus differs completely from the color-slide projected on the wall. I would not rule out turning to

transparencies, although it would not be possible for the work in this collection. There would have to be a building where it would be possible to recreate the first transparencies of Europe, the stained-glass windows of the cathedrals, by modern photographic means.

C. G. P.: The size of your pictures has nothing to do with extraneous forces such as the art market. Your concern is only with aesthetic qualities, with the appearance of materials in their visual surfaces.

A.T. S.: There are sizes that are right and others that are wrong. It depends on the picture itself. The medium is the decisive factor at this point. The painter can choose a large or a small format upon which to start work. Yet the photographer always has a tiny negative, a fact that is often overlooked in specialist discussions. Normally, the size of the negative and proof print are considerably smaller than the later work. Thus I must always enlarge, which means making a decision during the work process that a painter would never have to make. For the large monochromes, I have a definite idea of the scale they should be, because then, color has a new property – namely that of energy. The perception of the waves that reach the eye from this red surface would be impossible on a smaller scale. A metamorphosis takes place here, a trans-

formation. A small object shown on a large scale has something like the microscope effect of rendering something visible. "Space pictures" is what some critics called my pictures in the Cologne exhibition at Museum Ludwig. I find this link between microcosm and macrocosm fantastic. I see many things on a small scale because I draw my elements from nature – like manifestations to which light gives a special quality, which might later be measured optically, in millions of light years.

C. G. P.: Do you not experience a degree of estrangement in your work, making color enlargements on Cibachrome or Ilfochrome and having to depend upon an outside laboratory?

A.T. S.: I use the material because of its permanence. I still want to be able to see, in the future, what I did ten years ago. And it is fairer to the people who buy my work. I don't sense much estrangement working with a laboratory, as I frequently intervene in the work process. Artists like Robert Häusser, whom I personally admire, have admitted to going no further with photography, so as not to become dependent on the colors supplied by chemistry. A massive outlay in materials is often necessary before I can achieve the result I have actually envisaged. In economic terms, this means that for every large

Ciba or Ilfo four prints and countless trial strips have to be discarded.

C. G. P.: Laboratory: darkroom and scienstific lab, pecise calculatoin and chance. You have to know fairly exactly what you are doing, although there is always a certain element of unpredictability. A picture could result which you might never have reckoned with.

A.T. S.: I approach the final result, the large work, in stages, with a series of trials on a smaller scale, about A4 size. The element of chance certainly plays a part. Here we touch the chaos theory. It is fantastic I haven't reckoned with it, and yet something has happened by which I am surprised! The best way forward is to consciously take up the surprise element, recognise it as something positive and to continue systematically – much like in biology, when a mutation, a kind of genetic error, turns into something positive.

C. G. P.: A very exciting creative process!

A. T. S.: Absolutely! I would not be happy if everything went too smoothly. Color reversals can always be computer-generated. I have tried this out, but found that what you don't get is the element of chance.

C. G. P.: Let's compare the large blue picture with its mat surface and the red, glossy one, nearer the window at the moment – a work presentation. You want the picture surface to be flat, as you have a definite concept of what effect your pictures should achieve.

A.T. S.: Photography has something of a dematerialising quality, with a surface which may be of glossy, high gloss or mat effect, but which bears no trace of three-dimensional relief. Indeed, a mat Ilfochrome does have a certain materiality – but only a rudimentary materiality. This brings me back again to light itself. I love exhibition spaces which are naturally lit, so that a picture works differently under the influences of changing time by day and night. I avoid using spot-lights, not for reasons of conservation, but because they make my pictures always look the same. It is wonderful to sit in my studio with no artificial lighting, thinking or writing; watching daylight fading through the large windows. The blue forms in the mat picture begin to float more and more, and reach perhaps their finest quality at the point at wich they are just barely still discernable. The factor of time plays a part, here, too.

As soon as I speak about color, I have to mention – and think about light. The lighting of my pictures is crucial, although they "function" (horrible word) in any light. To me it is very important that they look different under weak and strong.

C. G. P.: You don't want to put the viewer in a straight-jacket, simply to show him ways to look at your work. The idea of dematerialisation was central to the aesthetic theory and practice of Moholy-Nagy. I find your answer quite fantastic, in the way so many strands seem to come together and circles close again.

A.T. S.: An interesting fact – I was not aware of this aspect of Moholy-Nagy's work. This leads me back to the Cologne exhibition, *Light shines only in the Dark*. There, I added strips painted with acrylic to the photographs. These were not only intended to refer to eternity, as the curator expressed it at the time. They had more to do with the theme of painting. Interestingly, what looked particularly "painterly" was the technically produced photograph, and the acrylic-painted strip had a particularly technical character. I don't do that in this exhibition. I don't want to distract the eye in any way from the "places". Yet I am not ruling out the possibility of painting large monochrome pictures sometime in the future. My themes are the materialisation of phenomena and their dematerialisation. Therefore I present some pictures without glass. The small screen mentioned before, and reproduction itself are another vast area for discussion. Even to the "enlightened public" photography is known extensively only through the print media. One example by way of illustration: if I reproduce Picasso's *Guernica* in *Stern* it is obvious to everyone that this is a reproduction of a painting. If I print a photograph by Hilmar Pabel from the war in Vietnam, I can easily imagine the original, although a bit more thought would reveal that an artwork has an aura which cannot be reproduced. And this brings us to Walter Benjamin. It is not simply my opinion, but an actual fact that a photograph has its own aura which is altered though reproduction, no matter whether in a catalogue, a newspaper or a magazine – just as it does in the case of painting. This does not necessarily signify a loss, but in any event reproduction inevitably alters a picture. It is simply that people are not really acutely aware of this. Consequently, I think one of the most important aspects of the development of art over the past ten or twenty years has been the fact that more and more people are seeing the medium of photography in its original form, without the print reproduction in between.

C. G. P.: Exhibitions are an important medium in this regards – a fact people probably don't appreciate unless they have worked as a curator. True, to a certain extent you can take the idea home as visual information in the printed catalogue, but that doesen't mean you've got the original in your bag.

A.T. S.: That is correct. It is a particular problem for photography. A concrete image which I reduce still retains its structures on a small scale. A two-square-metre work whose nature is based on the photographic blurring at that scale, poses a great problem. If I reduce this large blue picture to catalogue-format of about 15 x 20 cm, I suddenly have a picture of razor-sharp precision. This I do not want, and to avoid it I have to blur the small-scale work again. The historical categories of "sharp" and "blurred" are beset with positive and negative values (pictorialism versus straight photography) which are of no interest for me or my work. I either want this effect, or I don't. The point is that discussion of these matters can only be generated by an exhibition, not through an illustration in the catalogue.

C. G. P.: Without lumping painting and photography together, color pigment plays a role in both painting and Cibachrome and Ilfochrome work alike. To me, this is paradox.

A.T. S.: C prints (color prints) receive their color through oxidation at the moment of development, while the color pigment is stored in layers in the Ilfochrome paper. This influences my mental approach, because I'm made aware in a sentient way of how (to put it very simply) that process "washes" out the colors, raises them

up. The actual theme of the pictures in this exhibition is not really any particular content nor the depiction of any particular thing – it is the exploration of photography itself. In some respects we're spanning a bridge to the "Bielefeld School" (Gottfried Jäger and Karl Martin Holzhäuser), although its approach is quite different. I am not anxious about the kind of massive, sensuous aura generated by this red picture. A purist, on reflection, might find this too close to some other medium that he does not like. For me, this involves a calculated risk – should I or should I not make something which moves me accessible to others, given the danger of misinterpretation? But I have to take the risk; that's always been the way with me, and there are enough people who give me encouragement and tell me to go ahead.

C. G. P.: In my opinion, your photographic work has followed an incredibly cohesive course since the early eighties, one development building consistently upon the other.

A.T. S.: It makes me happy to hear you say that, and I think, if I may say so, that it also applies to the correlation between my representational photographs and the non-representational main theme in my work. We spoke at the outset about the opera theme. These works resulted partly from reflections about

whether the same mechanisms at work in my other pictures could be transferred to an "applied" context. I discovered that it worked. The principle of pictorial effect is the same. I am very glad that at some point about fifteen years ago, after relentless work, I said to myself, "Now I'm going to do nothing but photography". It is such a vast field! I realize only now that exhibition has unintentionally become a kind of retrospective.

C. G. P.: In spite of this backward look – you have a lot going on, and I look forward to seeing what happens with the new color perspectives.

BIOGRAPHY

A.T. Schaefer

1944 Born in Ennigerloh,
Germany

Studied painting and design at the
Werkkunstschule, Hanover

Painting, kinetic sculptures

Work in photography since 1981

Solo Exhibitions (since 1983)

1983 "Farbige Bildwelten", Galerie
für Photographie, Braunschweig

"Albert T. Schaefer: Fotografien",
Galerie Günter Krauss, Stuttgart

1984 "Farbige Bildwelten",
PS Galerie, Bremen

"Albert T. Schaefer", Galerie
Jutta Rößner, Stuttgart

1985 "Fotografische Bilder", Galerie
Pro Photo, Nürnberg

1986 "Photoarbeiten", Kunstverein
Ludwigsburg

"Farbverwandtschaften",
Olympus Galerie, Hamburg

1987 "Fotografische Arbeiten",
Augustinermuseum,
Schwarzes Kloster, Freiburg

1988 "Malerische Photographie",
Internationale Photoszene, Cologne

1991 "Licht leuchtet im Dunkel",
Museum Ludwig, Cologne

1992 "A.T. Schaefer, Photographien
1989-91", Brandenburgische
Kunstsammlung, Cottbus

1994 "A.T. Schaefer, Konkrete
Photographie", Museum für
Konkrete Kunst, Ingolstadt

1995 Staatstheater Stuttgart,
Großes Haus, Stuttgart

1996 "Orte der Farbe, Arbeiten
1989-96", Kunsthalle Bielefeld

"Orte der Farbe, Arbeiten
1989-96", Museum für Kunst
und Gewerbe, Hamburg

Group Exhibitions

1984 Art 84, Basel, Galerie Jutta
Rößner, Stuttgart

1985 Art 85, Basel, Galerie
Lahumière, Paris

1986 Art 86, Basel, Galerie
Lahumière, Paris

1987 "Vom Landschaftsbild zur
Spurensicherung", Museum
Ludwig, Cologne

"Fotografische Bilder",
Deutscher Künstlerbund,
Kunsthalle Bremen

1988 Städtische Galerie Nordhorn

1989 "Das Foto als autonomes Bild",
Kunsthalle Bielefeld; Bayerische
Akademie der Schönen Künste,
Munich

"Dokument und Erfindung",
Haus am Lützowplatz, Berlin
Augustinermuseum, Freiburg

1990 Moore College of Art and
Design, Philadelphia Goldie
Paley Gallery

1993 "Vom Autochrome zum Ilfochrome", Deutscher Werkbund, Frankfurt

"Deutsche Kunst mit Photographie", Fototage Frankfurt

1994 "Uecker a Ca'Pesaro, A.T. Schaefer, 22 Photographien zum Werk von Günther Uecker", Ca'Pesaro, Venice

"Deutsche Kunst mit Photographie, Die 90er Jahre" Fotofuture, Nürnberger Messe, Nürnberg

1995 "Zeitgenössische Fotografie aus der Sammlung Gernsheim", Roemer- und Peliazeus-Museum, Hildesheim

"La fotografia contemporanea dalla collezione Helmut Gernsheim", Ikona Photo Gallery, Magazzini del Sale, Venice

Collections

Stiftung für die Fotografie, Switzerland

Kunsthaus Zürich, Zurich

Musée de l'Elysée, Lausanne

Staatsgalerie Stuttgart

Österreichisches Museum für Photographie, Vienna

Augustinermuseum, Freiburg

Museum Ludwig, Cologne

Passigli Collection, Florence

Sammlung Reinhard, Zurich

Sammlung Wick, Frankfurt

Sammlung Gernsheim, Lugano

Museum für Konkrete Kunst, Ingolstadt

Brandenburgische Kunstsammlungen, Cottbus

Museum für Kunst und Gewerbe, Hamburg

Kunsthalle Bielefeld

Sammlung Generali Deutschland, Munich

Art and Architecture

Universitätsklinik Ulm, 57 photographic works, 1988-90

Hauptverwaltung Rinol Renningen, photo-sculpture and 12 photographic works, 1990/91

Staatstheater Stuttgart, Großes Haus, 12 photo-murals, 1995

Publications

1983 "Mit der Kamera auf Goethes Spuren", *Art,* April

"Farbkreis", *Braunschweiger Zeitung,* April

1985 "Venice", *Profifoto,* March

"Mack Skulptur"
Since
1981 "Toscana", "Schottland", "Provence", "Venedig", "Wien", "Korsika", "Rom", Art Edition

1987 "Vom Landschaftsbild zur Spurensicherung", Catalogue, Museum Ludwig, Cologne

Annual Exhibition, Catalogue, Deutscher Künstlerbund

1988 R. Mißelbeck, "A.T. Schaefer", Catalogue, Internationale Photoszene Köln, Cologne

1989 Dr. Monika Bachmayr, "Autonomie der Farbe", *Baden-Württemberg,* Vol. 3

Dorothee Hammerstein,
"Das Foto als autonomes Bild",
Catalogue, Kunsthalle Bielefeld;
Bayerische Akademie der
Schönen Künste, Munich

1991 "A.T. Schaefer,
Photographien 1989-91",
Catalogue

Heiner Stachelhaus,
"Photographie wie Malerei",
NRZ, 5 March

Bruno F. Schneider,
"Raumschiffe im dunklen
Nebel", *Kölnische Rundschau,*
1 March

E. v. S., "Neuer Blick auf
Bekanntes", A.T. Schaefer im
Museum Ludwig, Cologne, *Kölner
Stadtanzeiger,* 1 March

1993 "Vom Autochrome zum
Ilfochrome, Höhepunkte der
Ilfordsammlungen", Catalogue,
Deutsche Fototage Frankfurt,
Frankfurt a. M.

"Deutsche Kunst mit
Photographie, Die 90er Jahre",
Catalogue, Deutsche Fototage
Frankfurt, Frankfurt a. M.

1994 U. Seitler, "Photographie
'Konkret' oder 'Gemalt'?",
Ingolstädter Zeitung, 21 March

Dr. Isabella Kreim, "Interview
A.T. Schaefer",Kulturkanal,
Bayerischer Rundfunk, 21 March

"Bozzetti di scena disegni di
costumi e foto d'epoca"
(Article on the photographs of
A.T. Schaefer for the work of
G. Uecker), *Nouva Venezia,* 19 March

R. Mißelbeck, Catalogue,
Fotofuture, Nürnberger Messe,
Nürnberg

1995 "Zeitgenössische Fotografie aus
der Sammlung Gernsheim",
Catalogue

Christian Marquart, "Visions
and Revisions at the Stuttgart
Opera", *German-American
Cultural Review,* Verlag
Internationes

A.T. Schaefer, "Oper in
Stuttgart", 1995
(Kodak Photobook Prize)

"Oper in Stuttgart, Buch und
Fotografische Wandtafeln",
Stuttgarter Nachrichten, 7 Oct.

"Bildband Oper in Stuttgart",
Stuttgarter Zeitung, 10 Oct.

W. Roesner, "A.T. Schaefer,
Buch und Fotografische
Wandtafeln", *Porträt, S2 Kultur
SDR/SW,* 12 Oct.

"A.T. Schaefer, Oper in
Stuttgart", *Südwest 3 Fernsehen.
Kultur Südwest,* 19 Oct.

"Kunst an Staatlichen Bauten
in Baden-Württemberg 1980-1995",
Verlag Cantz, Stuttgart

1996 "Orte der Farbe, Arbeiten
1989-96", Catalogue, Kunsthalle
Bielefeld; Museum für Kunst
und Gewerbe Hamburg;
Edition Stemmle, Kilchberg, Zurich

This publication is the official catalogue for the exhibition entitled
"A.T. Schaefer – Orte der Farbe", Kunsthalle Bielefeld and
Museum für Kunst und Gewerbe, Hamburg

Editor: Jutta Hülsewig-Johnen
Exhibition secretariat: Heide Krämer, Petra Tabbert
Administration: Carsten Andreas, Karin Marquardt
Technical support: Hildegard Lattrich, Walter Saloga, Johannes Boller, Reinhard Ratzka

Pictures copyright by A.T. Schaefer
Text copyright by the authors
Text edited by Nadjed el Khamash, Esther Oehrli and John S. Southard
Translation from the German by Heather Eastes and Stephen Reader
Art direction and cover design by Uwe Göbel, Thorsten Höning, Achim Pahlke,
Munich/Bielefeld, Germany
Photolithography by Colorlito Rigogliosi S.r.l., Milan, Italy
Printed and bound by EBS Editoriale Bortolazzi-Stei s.r.l.,
San Giovanni Lupatoto (Verona), Italy

ISBN 3-908162-25-4